IMAGES
of America

GUTHRIE AND
LOGAN COUNTY

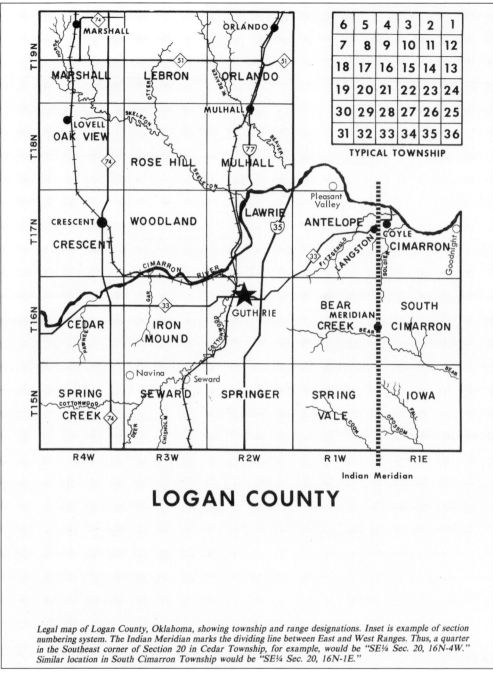

6	5	4	3	2	1
7	8	9	10	11	12
18	17	16	15	14	13
19	20	21	22	23	24
30	29	28	27	26	25
31	32	33	34	35	36

TYPICAL TOWNSHIP

Indian Meridian

LOGAN COUNTY

Legal map of Logan County, Oklahoma, showing township and range designations. Inset is example of section numbering system. The Indian Meridian marks the dividing line between East and West Ranges. Thus, a quarter in the Southeast corner of Section 20 in Cedar Township, for example, would be "SE¼ Sec. 20, 16N-4W." Similar location in South Cimarron Township would be "SE¼ Sec. 20, 16N-1E."

A COUNTY MAP. This map of Logan County was published in volume one of *The Logan County History: Families*, edited by Helen F. Holmes and published in 1978 by the History Committee of Logan County Extension Homemakers Council.

ON THE COVER: **THE FINAL INAUGURATION.** This image shows the inauguration of the last territorial governor of Oklahoma, Frank Frantz, on the steps of the Carnegie Library in Guthrie on January 15, 1906. (Courtesy Archives Division, Oklahoma Historical Society.)

IMAGES
of America

GUTHRIE AND LOGAN COUNTY

Glen V. McIntyre

ARCADIA
PUBLISHING

Published by Arcadia Publishing
Charleston, South Carolina

Printed in the United States of America

Library of Congress Control Number: 2010940843

For all general information, please contact Arcadia Publishing:
Telephone 843-853-2070
Fax 843-853-0044
E-mail sales@arcadiapublishing.com
For customer service and orders:
Toll-Free 1-888-313-2665

Visit us on the Internet at www.arcadiapublishing.com

To Joyce and Frank, Floyd Junior, and Katy—
the next generation to create history

CONTENTS

ACKNOWLEDGMENTS

Writing a book like *Guthrie and Logan County* was only possible with the help of many people.

I want to thank Bill Welge, director of the Archives Division of the Oklahoma Historical Society, and Terry Zinn, the photograph processor of the archives, who were very helpful and prompt in the delivery of materials.

I want to thank Nathan Turner, director of the Oklahoma Territorial Museum in Guthrie, and Erin Brown, also at the Oklahoma Territorial Museum, for taking so much time to help me with this project.

I want to thank Pam Leavengood, assistant archivist at the Cherokee Strip Regional Heritage Center in Enid, Oklahoma, for locating and scanning useful pictures of Marshall.

I want to thank Robert Bozarth of Bozarth Photography in Guthrie for allowing me to look through his enormous collection of early Guthrie images and choose some to use in this book.

I want to thank John Stanbro of Guthrie for allowing me to scan some of his postcard collection for use in this book. Bill Ward of Enid and Bill Diedrich of Marshall also provided photographs that were useful.

I also want to thank John Lovett and Jacki Slater their help at the Western History Collections. Milissa Burkart and Marc Carlson were instrumental in helping me acquire a photograph from the Special Collections at the McFarlin Library of the University of Tulsa.

I want to thank Kay Bost and Kate Blalack for help in acquiring the photograph of Angie Debo from the Edmon Low Library at Oklahoma State University.

My friend Jim Jackson is always helpful in going through flea markets and was equally helpful finding images for this book. Also thanks to Jim for driving to Wichita, Kansas, and back to attend the Wichita Postcard Show.

As always, I can't say enough about Ted Gerstle and Joe Walker for their help at Arcadia Publishing. Without their assistance and that of John Pearson and Sandy Shalton, this book could not have been finished.

Though I did not dedicate this book to Mom and Dad (that dedication was in my first book on Kingfisher and Kingfisher County), they need to be remembered in any acknowledgment for their never-ending love and support.

INTRODUCTION

Logan County and its county seat, Guthrie, lie in north-central Oklahoma just to the north of Oklahoma City. The majority of the county was opened by the land run of April 22, 1889, which cleared the way for the central part of Oklahoma—called the "Unassigned Lands" or, sometimes, "Old Oklahoma"—to be settled. On September 6, 1891, the eastern portion of the county, which had been part of the Sac, Fox, Iowa, and Potawatomi Reservations, was opened by a land run.

Geographically, the county is roughly split between the wooded eastern portion of the county, part of the timber belt called the Cross Timbers, and the western portion, which is rolling prairie. The Cimarron River flows into the county from the northwest, then makes a broad turn to the north before turning to the east where the river forms the northeastern boundary of the county.

Guthrie was designated as one of two towns to have a land office (opened in 1889) in the Unassigned Lands; the other land office was is Kingfisher. Congress declared Oklahoma a territory by the Organic Act on May 2, 1890. The Organic Act called for Guthrie to be the capital of the new territory until the territorial legislature decided otherwise. Realizing the importance of having the capital in their town, citizens of Kingfisher and citizens of Oklahoma City conspired to get the territorial legislature to locate the capital in their town. Both cities were frustrated by the vetoes of the first territorial governor, George Washington Steele. Guthrie remained the capital throughout territorial times until Oklahoma became a state in 1907. It remained the capital through the first years of statehood. In 1910, however, a statewide vote declared Oklahoma City the capital of Oklahoma.

Territorial counties were laid out by the first governor, George Washington Steele. He called the county in which Guthrie was situated County Number One. It took some time to settle on a name; some called it Steele County to flatter the new governor. On August 5, 1890, the people of County Number One chose the name of Logan County, named after John Logan, a Union general who had won the Congressional Medal of Honor at Vicksburg and was very popular among Republicans at that time.

As the premier city of Oklahoma Territory, Guthrie grew quickly, and Logan County grew with it. In 1900, the census counted Logan County as having 26,563 citizens; 77 percent were white and 23 percent African American.

The strong African American presence in Guthrie reflected the influence of a Kansas African American man, E.P. McCabe. McCabe helped found the all-black town of Langston to the northeast of Guthrie. In 1897, he was instrumental in founding the Colored and Agricultural Normal School at Langston. This survives today as Langston University and is still a traditionally African American school.

Several other towns grew up in the county and still survive: Marshall (the home of one of Oklahoma's premier historians, Angie Debo), Crescent, Meridian, Coyle, Mulhall, and Orlando are all still around today. Others were not so lucky and have ceased to exist: Lovell, Navina, Seward, Pleasant Valley, Iconium, Dutcher, and Waterloo are just a few of the towns that have vanished.

After the 1910 vote that transferred the state capital to Oklahoma City, Guthrie fell asleep, as it were, for some 60 years. Because the town was no longer growing, its main streets remained much as they were in 1910 when the capital was moved (or stolen, as faithful Guthrie citizens would have it). Then, in the late 1970s and early 1980s, historians and architecture lovers discovered the charms of Guthrie. Such people have worked hard to restore many of its main streets to their original appearance.

The town of Crescent prospers as a small vacation destination, and Cimarron City has grown up just to the south of it. Langston remains a strong, viable African American university that continues the tradition it began in 1897.

This book concentrates on images showing the history and life of Guthrie and several other towns in Logan County from the land run of 1889 to roughly the end of the 1930s, concentrating mostly on the earlier period. Chapter one deals with Guthrie in the beginning. The land run and instant growth of a city was a new phenomenon and extensively recorded by photographers. Chapter two shows parts of many other Logan County towns as well as the continuing development of Guthrie. Chapter three concentrates on the many ways that people made a life in the new county. Chapter four considers transportation in this era, and chapter five looks at churches and schools. Chapter six contains photographs of some of the early settlers of Logan County, both famous and not so famous. The final chapter deals with the various ways people had fun in those times, some of which are still popular today.

This book reflects how Guthrie and Logan County remain monuments to the beginnings of Oklahoma.

One

BEGINNINGS

The beginning of Guthrie and of Logan County could not have been more exciting. The center of Indian Territory had not been given to any particular tribe, and pressure mounted to open this area to settlement.

On March 3, 1889, a "rider" named the Springer Amendment was attached to the Indian Appropriations Act, calling for the opening of the center part of Oklahoma. Pres. Benjamin Harrison issued a proclamation that the land would be opened on April 22, 1889. It insisted that no one should enter the land before noon on April 22, thus setting up the conditions for a land run.

Over 50,000 settlers gathered, most on the south side of the area along the South Canadian River and on the north side; few came from the east. Both men and women could take part, as long as they were over 21, but women had to be single, widowed, or divorced. African Americans could and did take part, many in Logan County. Native Americans could not participate, as they were not yet considered citizens. A person had to live on the homestead and "prove it up"—build a house and barn and raise crops—in order to assure that the land had not been obtained to sell on speculation.

Guthrie lay on the Atchison, Topeka and Santa Fe Railway (known as the Santa Fe), so many settlers came by train. There were so many settlers at Guthrie that they could not be contained in the original townsite and so formed the communities of West Guthrie, East Guthrie, and Capitol Hill.

Chaos reigned at first and there were town lot riots and a few murders, but Guthrie soon stabilized and flourished.

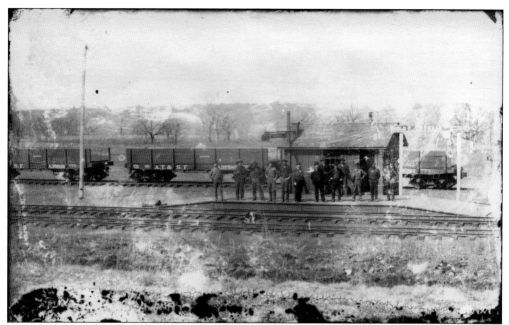

GUTHRIE RAILROAD DEPOT. Before the land run of April 22, 1889, Guthrie did not exist. In 1887, the Santa Fe built a north/south line through Oklahoma. This photograph shows the depot before the land run. Included in the image are the following: sixth from the left is Dr. Rogers, seventh from the left is A.W. Sawyer, eighth from the left is S.H. Radebaugh, and tenth from the left is the unidentified operator of the Guthrie Depot. (Courtesy Archives Division, Oklahoma Historical Society.)

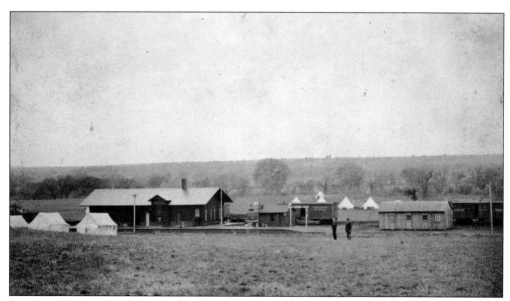

DEPOT AND TENTS. Just before the land run, soldiers were sent to maintain order. Shown is the depot with some of the soldiers' tents. (Courtesy Archives Division, Oklahoma Historical Society.)

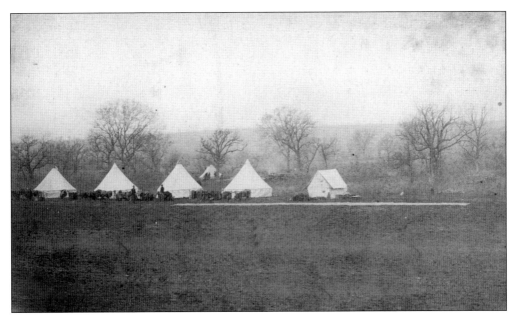

CAMP CARSON. Here is a close-up of some of the soldiers' tents. This section was called Camp Carson, named after one of the soldiers. The overall commander of the unit was Capt. Arthur MacArthur, the father of World War II commander Gen. Douglas MacArthur. (Courtesy Archives Division, Oklahoma Historical Society.)

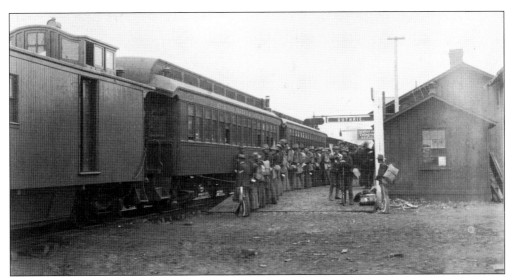

SOLDIERS GUARDING THE TRAINS. Settlers in the land run were allowed to come in by train. These soldiers are guarding the trains to make sure no one gets off before high noon, April 22, 1889. (Courtesy Archives Division, Oklahoma Historical Society.)

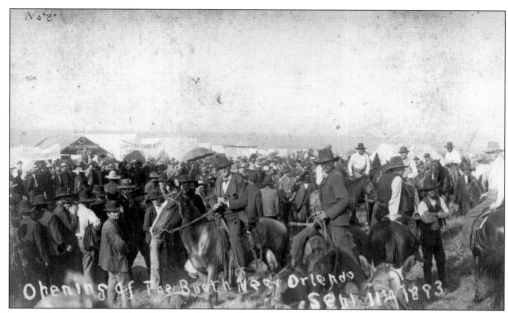

LAND RUN OF 1893. This photograph actually shows settlers gathering at Orlando, in northern Logan County, for the land run of September 16, 1893. It gives a pretty good idea of what things would have looked like in the 1889 land run. (Courtesy Archives Division, Oklahoma Historical Society.)

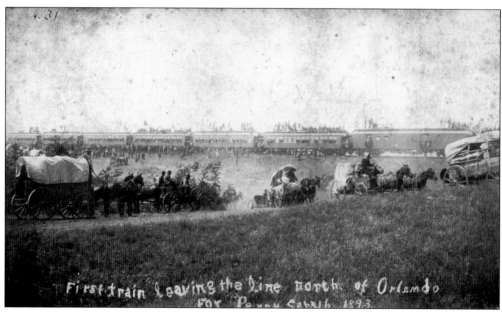

WAGONS AND TRAINS. This photograph is also of the land run of 1893, showing the first train leaving the line north of Orlando heading for Perry, but similar scenes could be seen in the 1889 land run. (Courtesy Archives Division, Oklahoma Historical Society.)

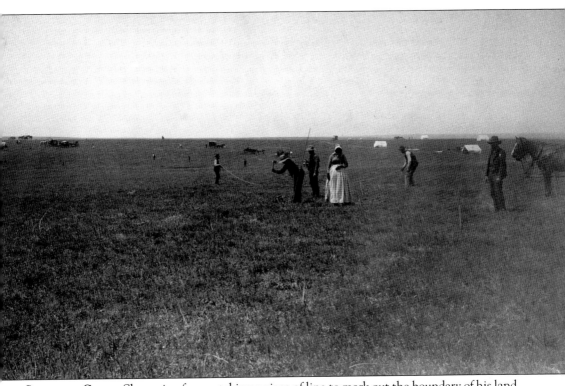

STAKING A CLAIM. Shown is a farmer taking a piece of line to mark out the boundary of his land. They had to live on the parcel for five years and make improvements to show that they were not claiming the land for speculation but to make a home. (Courtesy Archives Division, Oklahoma Historical Society.)

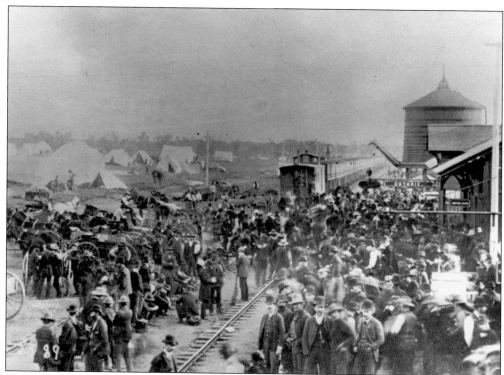

GUTHRIE, DAY TWO. This photograph shows the activity at the railroad depot the day after the run, April 23, 1889. In the background, the tent city of Guthrie is already rising on a once barren prairie. (Courtesy Archives Division, Oklahoma Historical Society.)

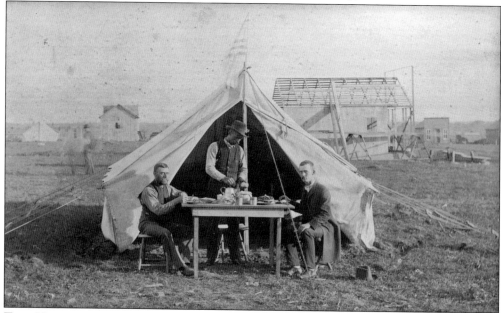

TENT HOME IN GUTHRIE. These three men have set up a home and are trying to achieve a little culture. From left to right, the men are John G. Rahner, A.S. Jacoby, and W.T. Bonham. (Courtesy Archives Division, Oklahoma Historical Society.)

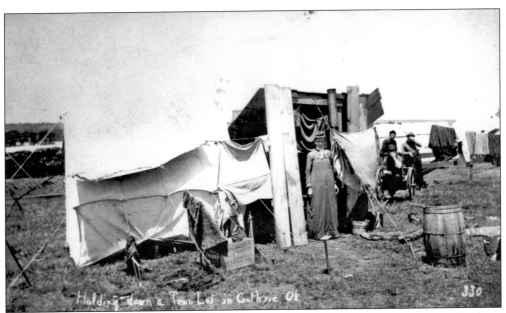

WOMAN AT HER TENT HOME. This unidentified woman's tent home in Guthrie is probably closer to the general reality of the tent homes than is shown in the prior photograph. (Courtesy Archives Division, Oklahoma Historical Society.)

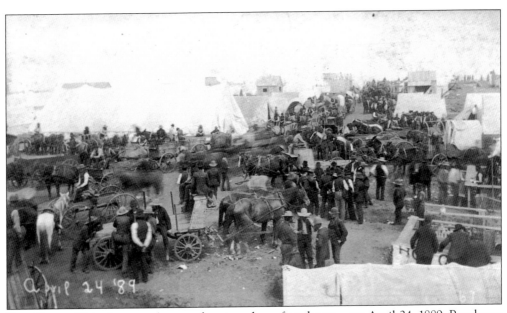

DAY THREE. This photograph was taken two days after the run, on April 24, 1889. People are trying to set up homes, but as it was not clear where the streets should have been, chaos ruled. (Courtesy Archives Division, Oklahoma Historical Society.)

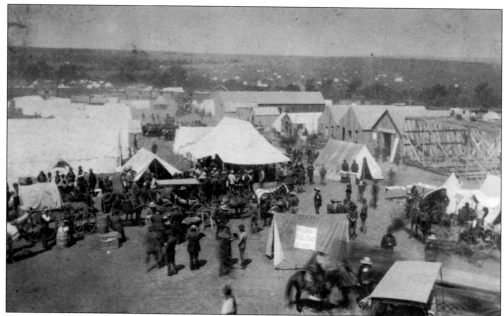

CONSTRUCTION BEGINS. A few days later, things started to settle down. People began constructing frame buildings for stores and offices, as can be seen in this photograph from April 27, 1889. (Courtesy Archives Division, Oklahoma Historical Society.)

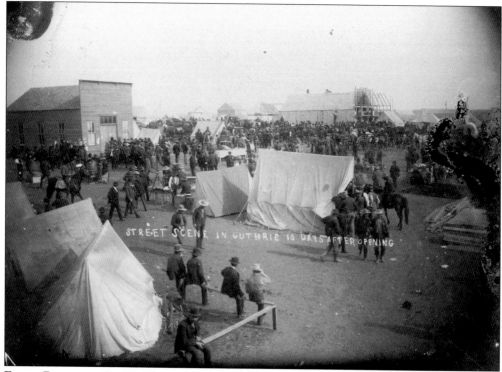

STREET SCENE IN GUTHRIE 10 DAYS AFTER OPENING

FRAME BUILDINGS GO UP. This picture is dated May 1, 1889, about a week and a half after the opening. The frame building is the land office that stood about where the current post office stands. (Courtesy Archives Division, Oklahoma Historical Society.)

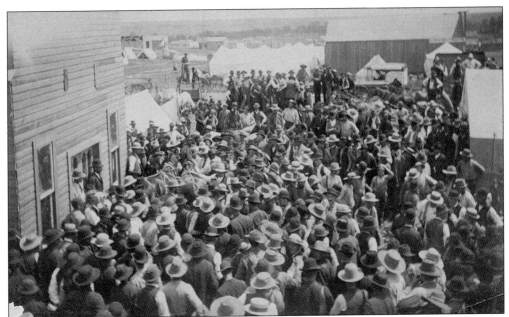

TOWN LOT RIOT. The details of this riot are vague. Some archives have this photograph labeled as "Town Lot Riot, May 22, 1889," while others have it "the first eviction." The latter would indicate that authorities were trying either to evict people nicknamed "Sooners" (as they had come onto the land sooner than they should have) or perhaps to evict people whose lots were overlapping on those of others. Either way, it was a problem. (Courtesy Oklahoma Territorial Museum, Guthrie, Oklahoma.)

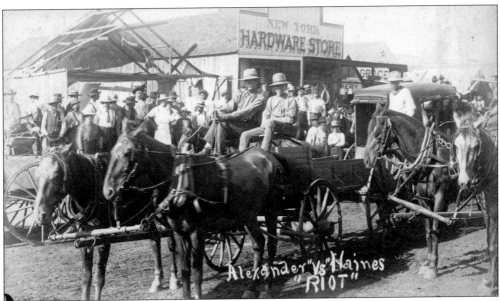

ANOTHER LAND DISPUTE. This photograph is labeled, "Alexander vs. Haines, Riot." Presumably, this shows two families in dispute over a town lot. (Courtesy Oklahoma Territorial Museum.)

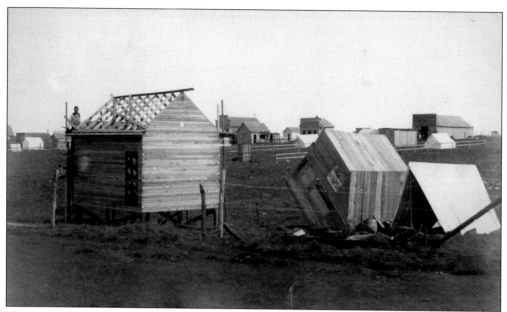

HOUSES OVERTURNED. This photograph is labeled, "The way they eject in East Guthrie, June 6, 1889." It seems to imply that someone would turn over a house and possibly drag it away if it was believed that the owner was on his or her land. (Courtesy Archives Division, Oklahoma Historical Society.)

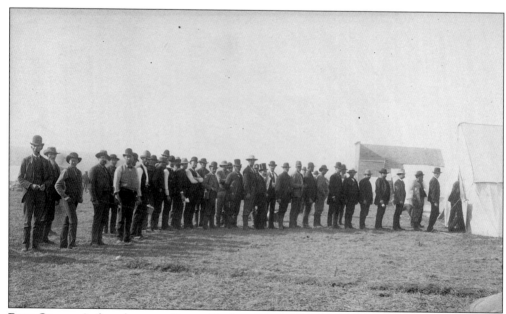

POST OFFICE. At first the post office at Guthrie was just a tent. Here, men line up to get mail on April 23, 1889. (Courtesy Archives Division, Oklahoma Historical Society.)

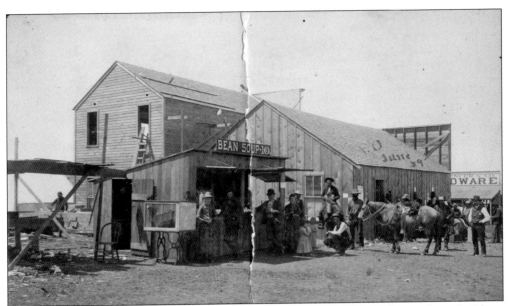

BEAN SOUP AND THE POST OFFICE. By June 1889, the post office had moved into a frame building. In this picture, it is the frame building to the right of the Bean Soup Restaurant. (Courtesy Oklahoma Territorial Museum.)

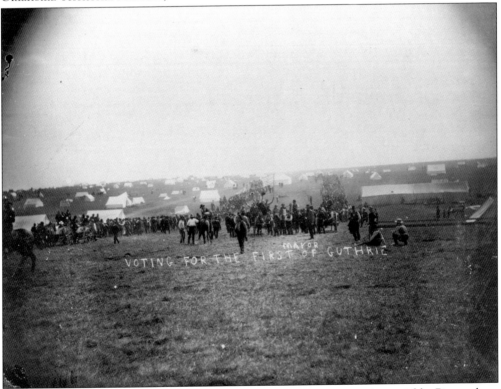

VOTING. Despite the chaos, everyone wanted to get a government going quickly. Pictured are men lined up to vote for the first mayor of Guthrie. (Courtesy Archives Division, Oklahoma Historical Society.)

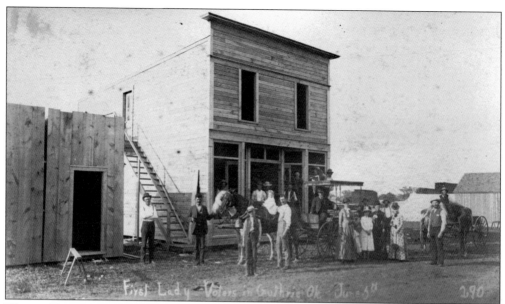

WOMEN VOTING. Even though women were not allowed to vote in state or national elections in most areas at this time, in Guthrie they were allowed to vote for local elections. Taken in Guthrie on June 5, 1889, this photograph shows women lining up to vote for the first time. (Courtesy Archives Division, Oklahoma Historical Society.)

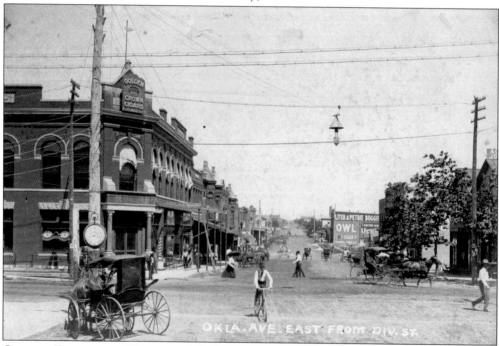

GUTHRIE ESTABLISHED. The town of Guthrie was established fairly quickly. From 1889 to 1907, it was the territorial capital of Oklahoma, and from 1907 to 1910, it was the capital of the state of Oklahoma. This photograph is looking east on Oklahoma Avenue from Division Street. The building on the left was called the Oklahoma Building and was the location of the office of several territorial governors. (Courtesy Archives Division, Oklahoma Historical Society.)

Two

TOWNS

Logan County had many other communities other than Guthrie. In far northern Logan County, right next to the boundary with the Cherokee Strip, was the town of Marshall, named for Marshalltown, Iowa, the hometown of townsite owner Syvan T. Rice. To the east was Mulhall, named for famous cowgirl Lucille Mulhall, then Orlando, named for Orlando Hysell, a relative of the townsite developer.

South of Marshall was Lovell, formerly Perth, named for James W. Lovell, the townsite owner. Near the Cimarron River was Crescent, possibly named for a crescent-shaped grove of trees near the townsite. Farther south, on the railroad from Kingfisher to Guthrie, was Navina, named for Lavina Berg, the daughter of townsite owner John Berg. Farther east on the railroad was Seward, named for William H. Seward, Pres. Abraham Lincoln's secretary of state and the man responsible for the purchase of Alaska. Meridian was east of Guthrie and named for the Indian Meridian upon which the town sat. Langston, the site of the Oklahoma Colored Agricultural and Normal College, was named for John N. Langston of Virginia, a prominent African American educator.

Other small towns, such as Dutcher, Lockridge, Iconium, and Pleasant Valley, as well as the farms in between, made up the fabric of Logan County.

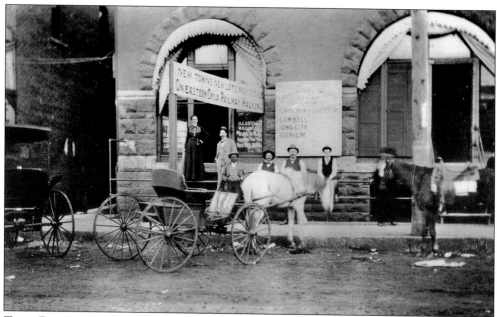

TOWN PROMOTING. Here, the Eastern Oklahoma Railway is promoting the towns of Campbell, Iowa City, and Iconium. Campbell later became the town of Pleasant Valley, Iowa City became Coyle, and Iconium was a small town five miles northeast of Meridian on the "Peavine Railroad." (Courtesy Bozarth Photography.)

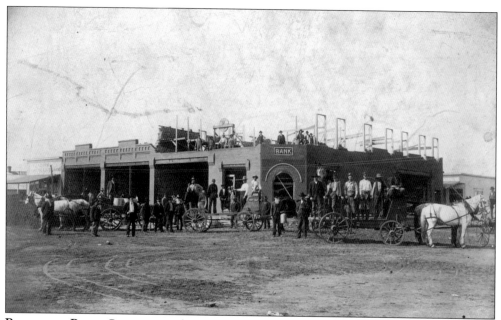

BUILDING A BANK. Crescent, on the western side of Logan County, became a successful town. Here, they are building the old Farmers and Merchants Bank at Crescent sometime around 1905. (Courtesy Archives Division, Oklahoma Historical Society.)

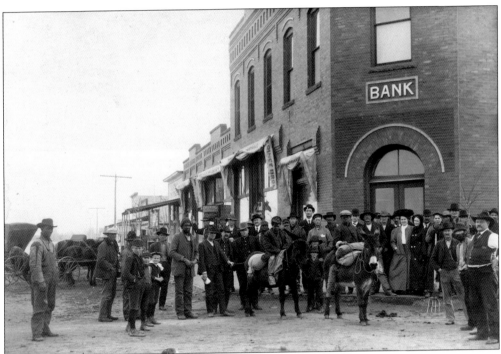

ACTIVITY AT THE CRESCENT BANK. These banks often became the centers of local activity. Here, some men on donkeys have attracted a crowd in front of the Crescent bank. (Courtesy Archives Division, Oklahoma Historical Society.)

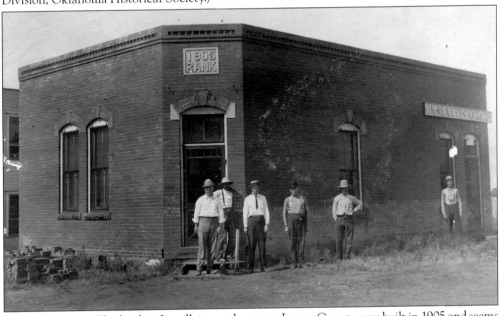

BANK AT LOVELL. The bank at Lovell, in northwestern Logan County, was built in 1905 and seems to have had the same architect as the bank at Crescent. O.B. Acton started the bank and was its president. He is pictured here (third from the right in the group in front) with Frank Weldon (second from the right in this same group); the other men are unidentified. (Courtesy Archives Division, Oklahoma Historical Society.)

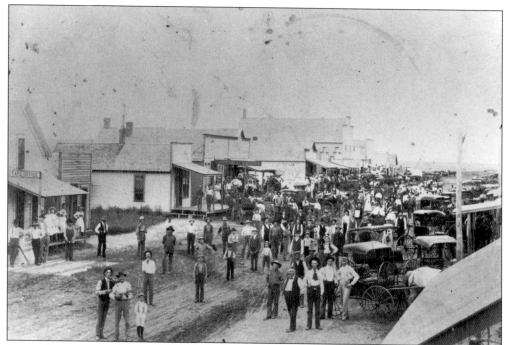

EARLY DAYS IN MARSHALL. Another once-successful town in far northern Logan County was Marshall; it was established on March 1, 1890. This photograph captures the early days in Marshall. (Courtesy Cherokee Strip Regional Heritage Center.)

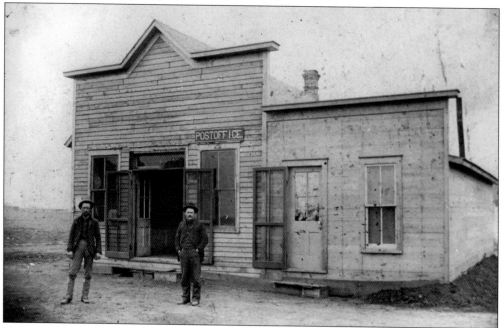

NAVINA POST OFFICE. Some towns were small from the beginning. The original townsite name for Navina was Berg. The post office was named Navina on October 2, 1900, after Lavina, daughter of the original townsite owner, John Berg. In this 1900 photograph, Berg (right) stands with an unidentified man. (Courtesy Western History Collections, University of Oklahoma.)

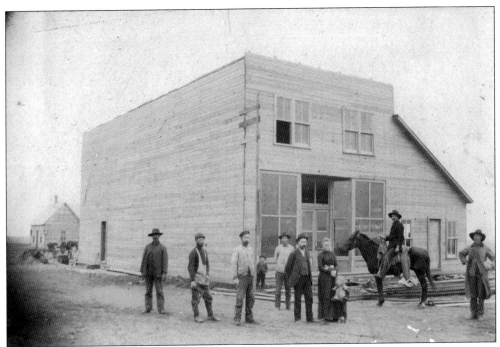

NAVINA'S GROWTH. What growth Navina did have was because it stood on a rail line that went from Kingfisher to Guthrie, nicknamed the Peavine. Railroad. In this picture, L.J. Stark is the man in the center wearing a bowler hat. (Courtesy Oklahoma Territorial Museum.)

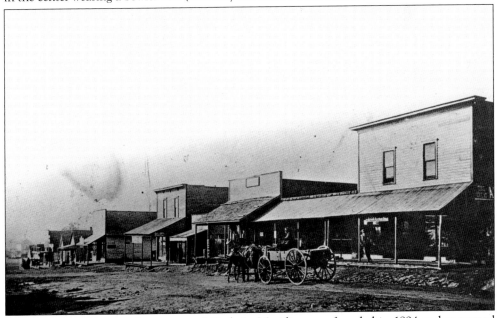

A STREET IN MERIDIAN. Lying east of Guthrie, Meridian was founded in 1894 and so named because it lies on the Indian Meridian, the dividing line in Oklahoma for the legal description of land. The large foreground building is the drugstore, and next to it sits the post office, a meat market, and a grocery. All of these structures burned in a major fire in 1908. (Courtesy Western History Collections, University of Oklahoma.)

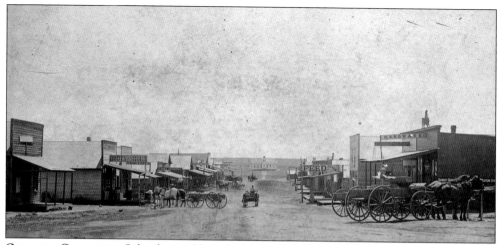

ORLANDO COMMERCE. Orlando, established on July 18, 1889, sits in far northern Logan County. The town was prominent briefly in 1893, as it was the location for one of the booths where settlers signed up for the Cherokee Strip land run of 1893. (Courtesy Western History Collections, University of Oklahoma.)

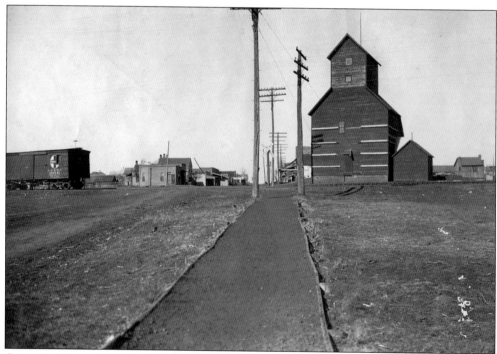

ORLANDO GRAIN ELEVATOR. Orlando was located on the Santa Fe Railroad, which was built through town in 1887. As in many other towns (such as Pleasant Valley), the grain elevator was one of the most important buildings in town. (Courtesy Western History Collections, University of Oklahoma.)

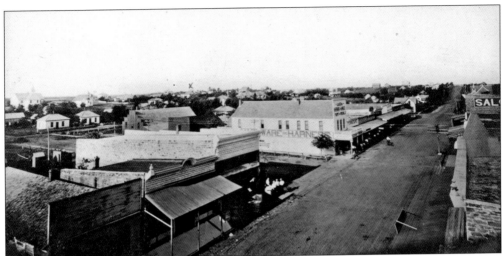

A BIRD'S-EYE VIEW OF COYLE. The townsite of Coyle was originally named Iowa City. The post office was opened May 5, 1900, and named for William Coyle, a prominent Guthrie businessman. Shown here is a c. 1907 view of Coyle, looking west. (Courtesy Archives Division, Oklahoma Historical Society.)

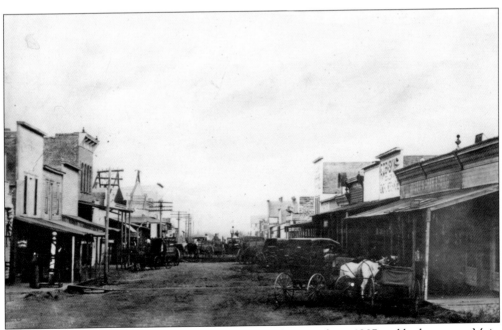

BUSINESS ACTIVITY IN COYLE. This picture of Coyle dates to about 1907 and looks east on Main Street. The congestion at the end of the street may be due to people waiting to unload at the cotton gin. If that is correct, it would mean the picture was taken during the fall harvest season. (Courtesy Western History Collections, University of Oklahoma.)

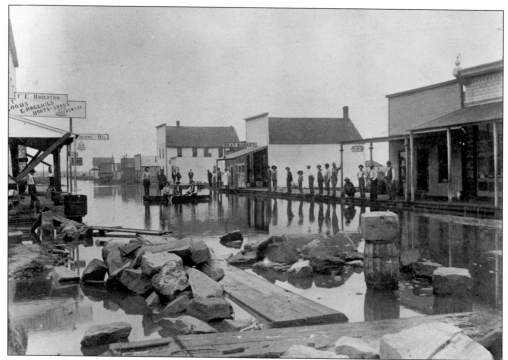

FLOOD IN COYLE. Coyle lies near the Cimarron River and occasionally floods; this is a good example in early years. The stones in the foreground of the image are from a construction project. (Courtesy Western History Collections, University of Oklahoma.)

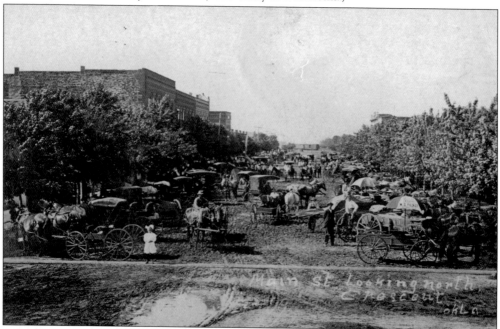

MAIN STREET, CRESCENT. Crescent was founded on January 21, 1890. Some books state that it took its name from a crescent-shaped ring of nearby blackjack oaks. This photograph is of Main Street, looking north. (Courtesy Oklahoma Territorial Museum.)

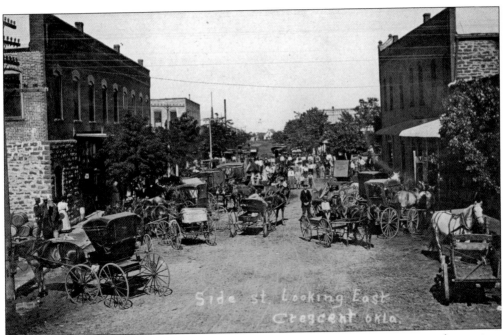

A Crowded Street in Crescent. This picture, presumably taken at the same time as the previous image, shows a side street in Crescent, looking east. (Courtesy Oklahoma Territorial Museum.)

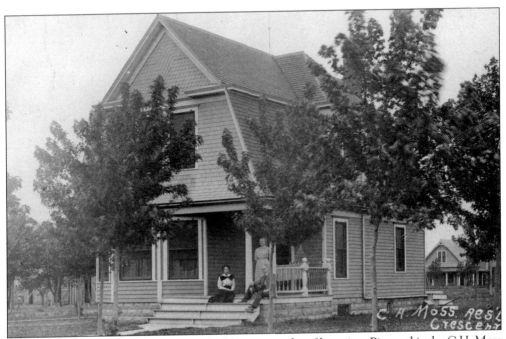

A House in Crescent. All the towns had homes worthy of boasting. Pictured is the C.H. Moss residence of Crescent. (Courtesy Oklahoma Territorial Museum.)

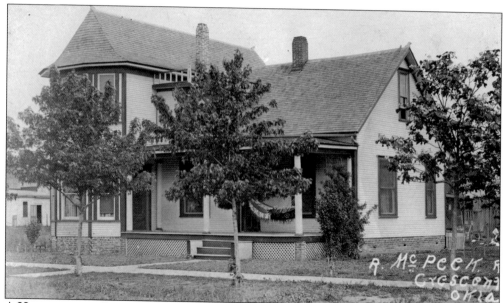

A HAMMOCK ON A PORCH. Shown here is the R. McPeek residence of Crescent. Hammocks must have been popular, as they are seen hanging on the porch of this house and the one shown on the previous page. (Courtesy Oklahoma Territorial Museum.)

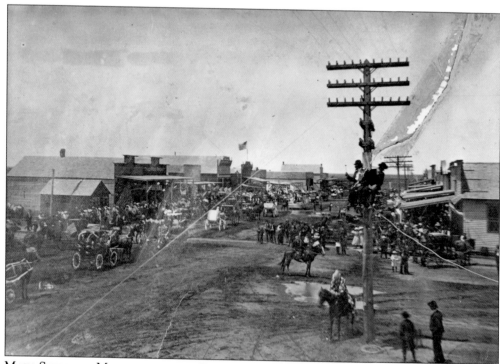

MAIN STREET IN MARSHALL ON THE FOURTH OF JULY, 1903. All towns became the center of activity for residents as well as people who would travel from many miles away. (Courtesy Western History Collections, University of Oklahoma.)

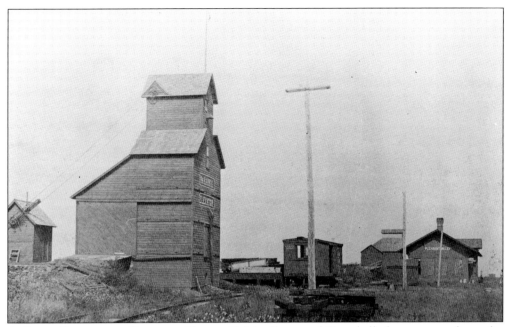

A Grain Elevator in Pleasant Valley. Originally named Campbell, the town was five miles northwest of Coyle. This photograph of the grain elevator dates to about 1908. One booster pamphlet from the early days claimed that Pleasant Valley shipped 2,000 to 3,000 bushels of grain annually. (Courtesy Western History Collections, University of Oklahoma.)

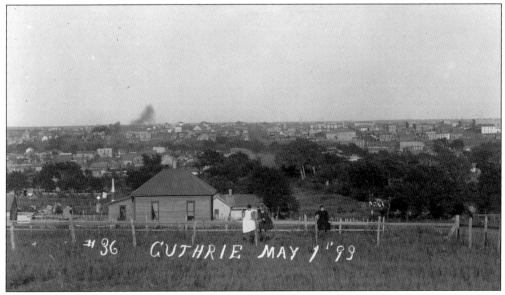

A Panorama of Guthrie. This view of Guthrie, taken on May 1, 1893, shows that Guthrie, as the territorial capital and county seat of Logan County, continued to grow. (Courtesy Archives Collection, Oklahoma Historical Society.)

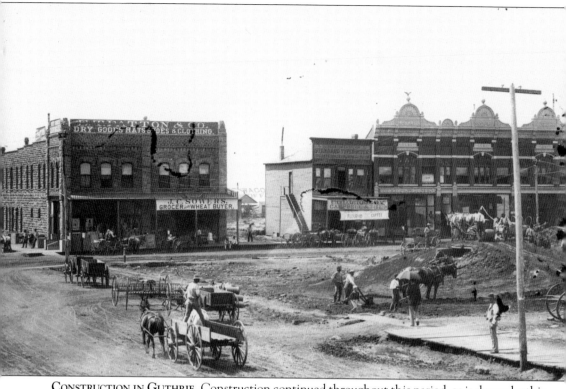

CONSTRUCTION IN GUTHRIE. Construction continued throughout this period, as is shown by this photograph of a construction site. (Courtesy Archives Division, Oklahoma Historical Society.)

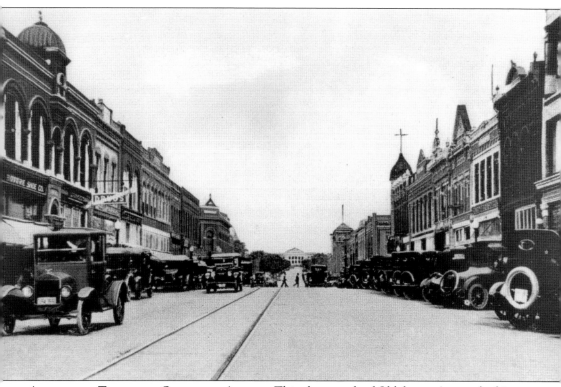

Automobile Traffic on Oklahoma Avenue. This photograph of Oklahoma Avenue looking east dates from the 1920s. At the end of the avenue, is the Masonic Lodge; it almost looks as though it has been drawn into the picture. (Courtesy Bozarth Photograph.)

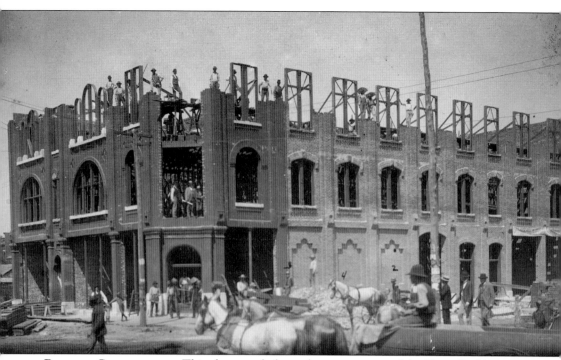

BUILDING CONSTRUCTION. This photograph shows the construction of the Victor Building at 118 East Oklahoma Avenue. It was erected in September 1893 by W.S. Smith. (Courtesy Oklahoma Territorial Museum.)

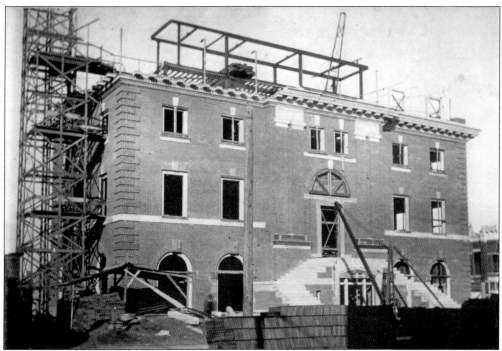

A Post Office under Construction. Seen here is the construction of the handsome Guthrie Post Office, which stands to this day. (Author's collection.)

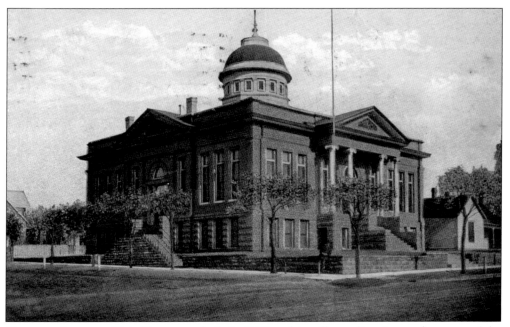

Carnegie Library. This library was built in 1902 and is still standing. It was the scene of the inauguration of the last territorial governor of Oklahoma, Frank Frantz, on January 15, 1906. (A picture of this inauguration is shown on the cover.) It was also the site of the inauguration of the first state governor, Charles Haskell, on November 16, 1907. (Author's collection.)

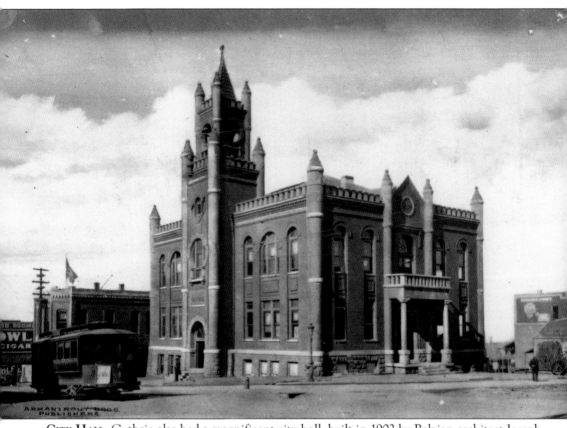

CITY HALL. Guthrie also had a magnificent city hall, built in 1902 by Belgian architect Joseph Foucart. It was used for the Oklahoma State Constitutional Convention of 1906–1907 and is sometimes called Convention Hall. Unfortunately, the building was torn down in 1955. (Courtesy Archives Division, Oklahoma Historical Society.)

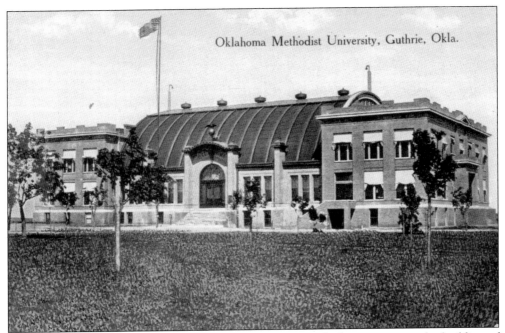

Oklahoma Methodist University, Guthrie, Okla.

STATE LEGISLATURE BUILDING. Because the state legislature had not constructed a building of its own, in 1908 the City of Guthrie constructed a building in which the legislature could meet. The short-lived Oklahoma Methodist University, the predecessor of present-day Oklahoma City University, later used this building. (Courtesy John Stanbro.)

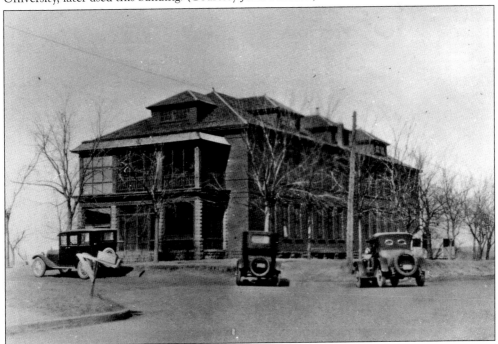

OLD HOSPITAL. As a growing city, Guthrie both wanted and needed to have a good hospital. This is a photograph of the old Methodist Hospital in far-northwestern Guthrie. It was taken after 1916, when the third story and the porch were added. (Courtesy Bozarth Photography.)

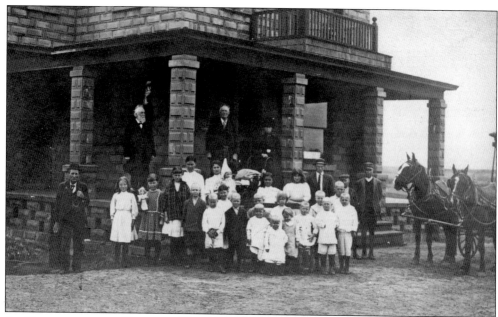

AN ORPHANAGE WITH CHILDREN. The Children's Home Society was founded on May 4, 1900, by Rev. Noah Wicham. (Courtesy Archives Division, Oklahoma Historical Society.)

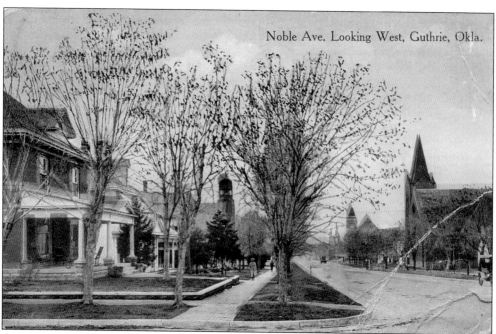

A RESIDENTIAL STREET SCENE. Guthrie had many fashionable streets lined with beautiful houses. This is Noble Avenue looking west towards what is still called "Church Row," so named because of its many churches. (Author's collection.)

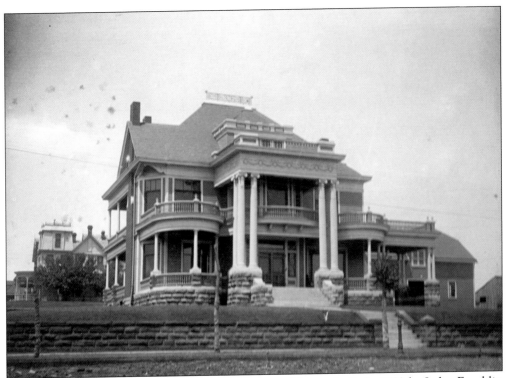

THE DALE MANSION WITH PILLARS. This neoclassical house, built in 1902 by Judge Franklin Dale, fronts Thirteenth Street on Cleveland Avenue. It featured a ballroom on the top floor and a formal dining room and drawing rooms on the lower floor. The house was full of decorative embellishments. It still stands today. (Courtesy Oklahoma Territorial Museum.)

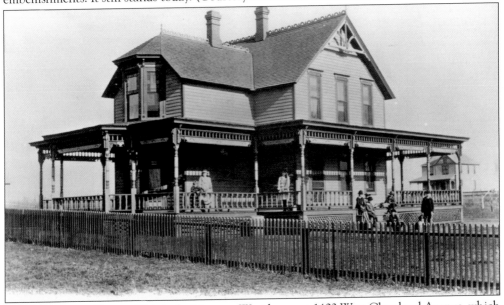

A HOUSE WITH A FENCE. This is the Magann-West house at 1403 West Cleveland Avenue, which was built in 1892–1893. Charles West was the first attorney general of the State of Oklahoma. (Courtesy Bozarth Photography.)

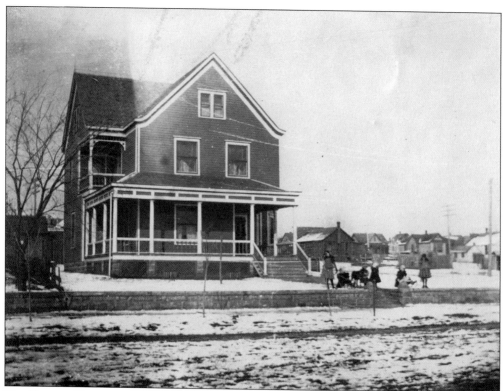

THE BELAND HOUSE IN THE SNOW. Pictured in this winter scene is the Beland house at 424 East Harrison Avenue. The house was later expanded considerably, but this picture shows it in its original state. (Courtesy Oklahoma Territorial Museum.)

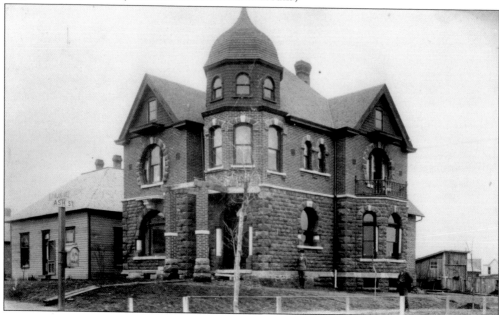

A STONE HOUSE WITH TURRETS. This is the Heilman house, designed by Joseph Foucart, which still exists today. (Courtesy Bozarth Photography.)

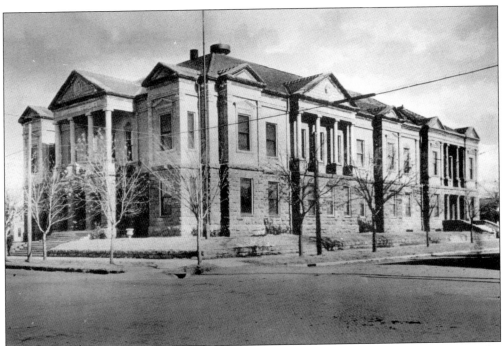

THE FIRST MASONIC TEMPLE. This is the first Scottish Rite Temple erected in Oklahoma. The cornerstone was laid on October 4, 1899, and the temple was first used on May 29, 1900. (Courtesy Bozarth Photography.)

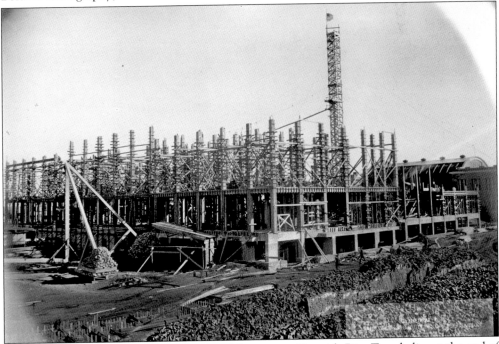

CONSTRUCTION OF THE CURRENT TEMPLE. The current Scottish Rite Temple lies at the end of Oklahoma Avenue. Construction began in June 1920. The old legislative building can be seen in the background of this photograph. (Courtesy Archives Division, Oklahoma Historical Society.)

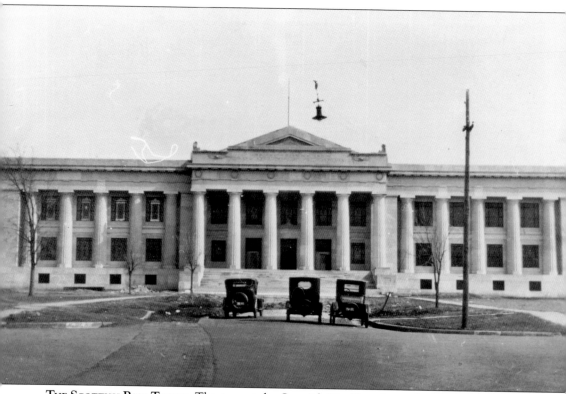

THE SCOTTISH RITE TEMPLE. The present-day Scottish Rite Temple was finished in 1929 at a cost of $3 million. (Courtesy Bozarth Photography.)

Three

MAKING A LIFE

Once settlers arrived, they began establishing new lives in their new towns. Both large and small towns had hotels. There were general stores and hardware stores, as well as saloons, brick makers, shoe stores, blacksmiths, banks, barbers, and newspapers. Towns had firemen and mailmen. Guthrie was settled after the telephone had been invented, so it had a telephone exchange. It also had an ironworks and a cigar factory.

Meanwhile, out in the country, families settled on their 160-acre homesteads and tried to raise crops. Crescent sat on sandy soil that was good for raising watermelons. Guthrie was located at the edge of a solid range of timber called the "Cross Timbers," so wood was plentiful. West of Guthrie, the land spreads out into rolling prairies where the raising of wheat became very important. All across Oklahoma, cotton was still being raised, especially in eastern Logan County. The cotton market at Guthrie was an amazing sight, bringing thousands of people to the town on market day (see page 57). The cotton gin was an important institution in nearly every town.

In 1912, oil production began to grow in importance in Logan County. In the 1920s, an oil field just east of Marshall was very successful for a very brief period. The oil boomtown of Roxana quickly blossomed and then disappeared.

From 1906 to 1907, Guthrie was host to the Oklahoma Constitutional Convention, the goal of which was statehood. During this convention, the document for the founding of the state of Oklahoma was written. The original document still survives and is at the state capitol in Oklahoma City.

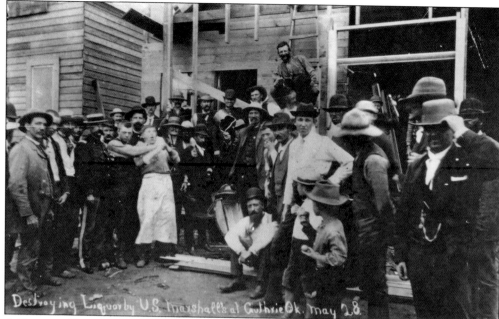

A CROWD IN FRONT OF THE SALOON. Guthrie had many saloons, even though Oklahoma Territory was supposed to be dry. This is a photograph from May 28, 1889, of US marshals destroying alcohol. (Courtesy Archives Division, Oklahoma Historical Society.)

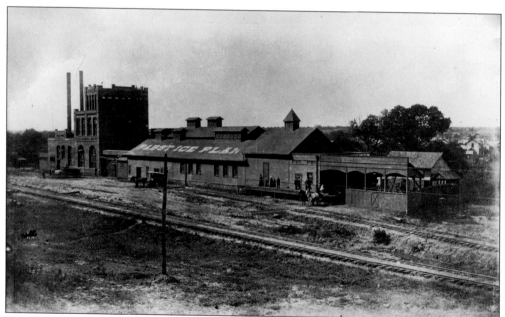

THE PABST ICE PLANT. The ice plant was located on the banks of Cottonwood Creek just off Noble Avenue. It had the capacity to make 50 tons of ice per day. Operated by Henry "Heinie" Braun, it continued as the Guthrie Ice Company after Oklahoma's prohibition of alcohol in 1907 forced the Pabst Brewing Co. distributor to close. (Courtesy Archives Division, Oklahoma Historical Society.)

BRICKYARDS. Many towns had brickyards. Pictured is the one in Guthrie, which opened in 1889. (Courtesy Archives Division, Oklahoma Historical Society.)

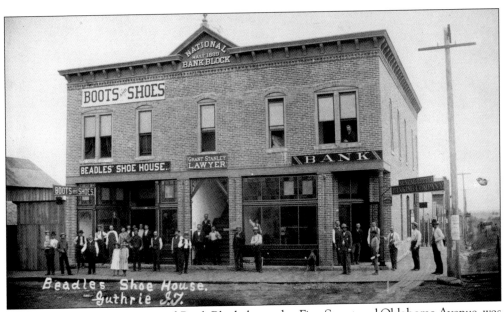

BOOTS AND SHOES. The National Bank Block, located at First Street and Oklahoma Avenue, was the first brick building in the territory. (Courtesy Oklahoma Territorial Museum.)

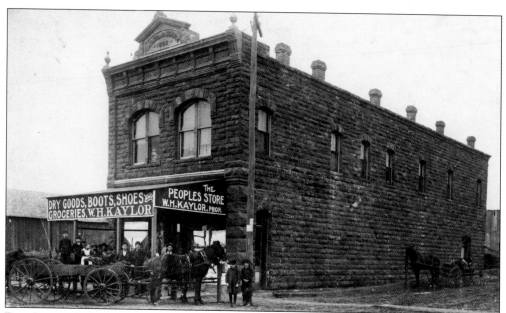

DRY GOODS. A dry goods store was a staple of every community. Guthrie had several, including this one pictured about 1894. (Courtesy Archives Division, Oklahoma Historical Society.)

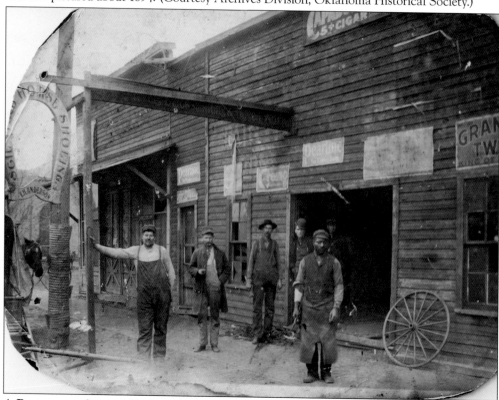

A BLACKSMITH SHOP. A blacksmith shop was another important staple. The blacksmith, shown in his apron and with the tools of his trade, is Mr. Anderson. His shop was on South Second Street. (Courtesy Oklahoma Territorial Museum.)

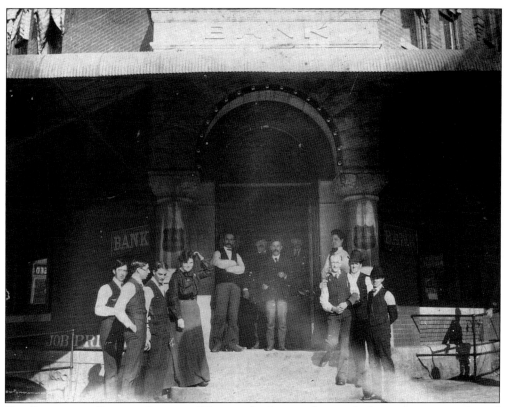

THE COMMERCIAL BANK OF GUTHRIE. Of course, banks were there at the beginning, as is evidenced by this photograph. (Courtesy Archives Division, Oklahoma Historical Society.)

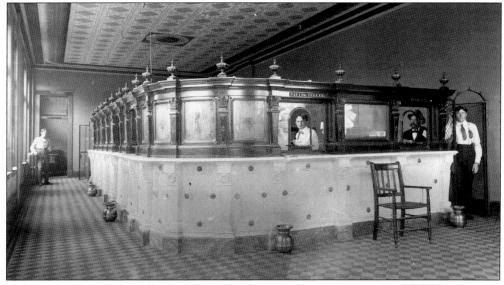

THE INTERIOR OF A BANK. The interiors of banks were often very impressive. This is the interior of the Farmers and Merchants Bank in Guthrie. John Gaffney is pictured to the far right, Erwin Edwin "Doc" Tallen is the man with the hat and moustache, and C. Havinghorst is the teller. (Courtesy Archives Division, Oklahoma Historical Society.)

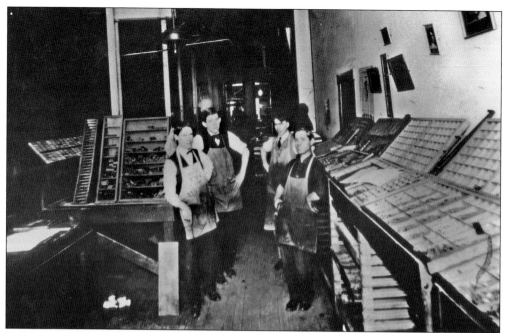

Composing Room. Newspapers played an important role in most towns, and Guthrie was no exception. Shown about 1911 is the composing room of the *Guthrie Daily Leader*. The type was still being set by hand at the time. (Courtesy Bozarth Photography.)

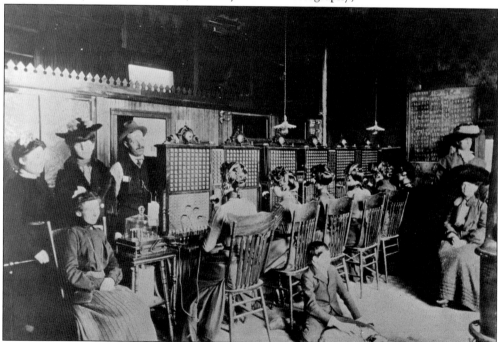

The Telephone Company, c. 1901. The Missouri and Kansas Telephone Company opened an office in Guthrie in May 1893, located at 111 1/2 South Division Street. The young boys seated on the floor were there to collect tolls owed by customers. (Courtesy Archives Division, Oklahoma Historical Society.)

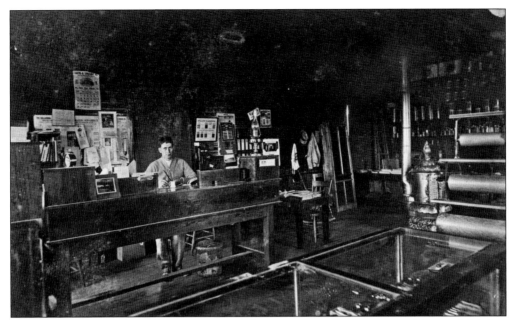

A GENERAL STORE. General stores were another mainstay of early communities, and this is a good example of one in Mulhall. The young man at the counter is either Jake Demal or Homer Speckelmeir. (Courtesy Western History Collections, University of Oklahoma.)

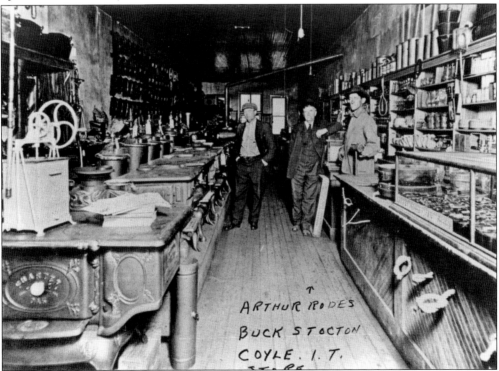

A HARDWARE STORE. This is a photograph of the hardware store in Coyle. The man in the center is Arthur Rodes, and to the left of him may be Buck Stocton. This store seems to have specialized in stoves. (Courtesy Bozarth Photography.)

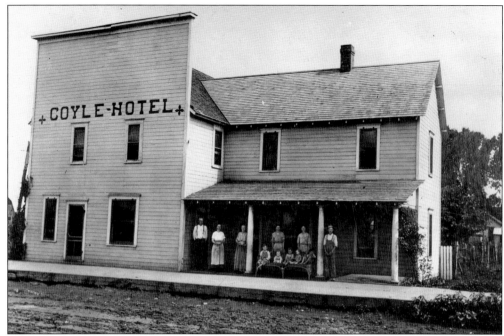

THE COYLE HOTEL, C. 1915. Even small towns like Coyle had hotels. Included on the hotel's porch are (sitting) Ralph Waltman, Violet Waltman, LaVana Bales, and Loren Bales; (standing, from left to right) W.C. Graham, Mae (Harris) Graham, Emma Iliff Graham, Livia (Graham) Waltman, Maggie (Graham) Bales, and Menzo Graham. (Courtesy Western History Collections, University of Oklahoma, Norman, Oklahoma.)

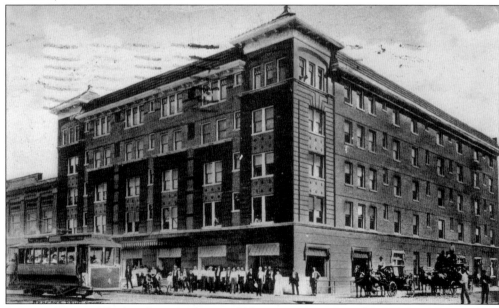

A LARGE HOTEL. The hotels in Guthrie could be very impressive. This is the Hotel Ione, built by William H. Coyle, which stood at the corner of Oklahoma Avenue and Wentz Street. Coyle named the hotel after his daughter Ione. It was the headquarters of the Oklahoma Republican Party while Guthrie was the capital. (Courtesy John Stanbro.)

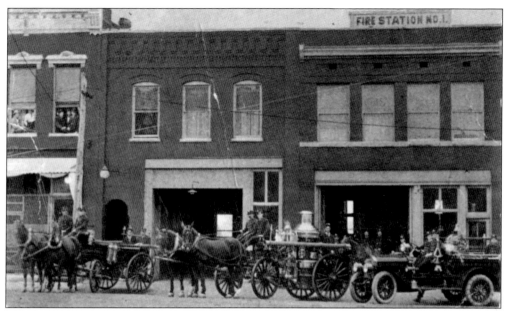

THE FIRE DEPARTMENT. A big city like Guthrie needed a fire department. This photograph shows the fire department in transition between horse-drawn engines and newfangled motorized engines (see chapter seven for the Firemen's Ball of 1895). (Courtesy Oklahoma Territorial Museum.)

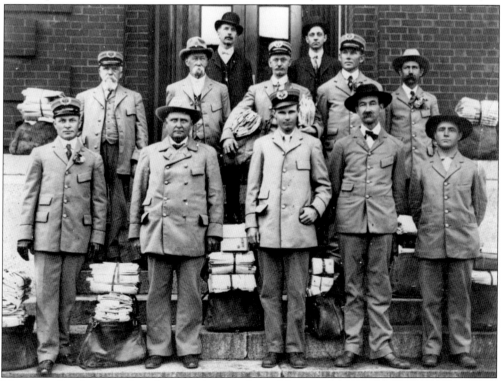

MAILMEN. By the time this photograph was taken, delivery of the mail had come a long way; consider the tent shown in chapter one that had been used as an early post office. (Courtesy Archives Division, Oklahoma Historical Society.)

51

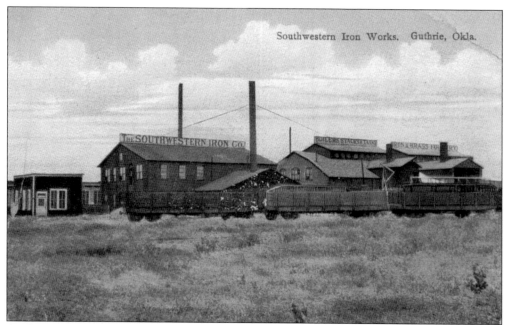

AN IRONWORKS. Guthrie, being the center of industry for the new territory, had its own ironworks. Shown is the Southwestern Iron Company. One of its products was the many iron manhole covers used on the streets of Guthrie. (Courtesy John Stanbro.)

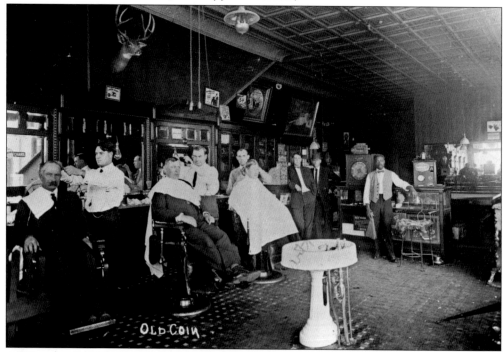

A BUSY BARBERSHOP. Guthrie had a barbershop called the Old Coin. It was located in the Pabst building at Second Street and Oklahoma Avenue. Customers could get a haircut, a shave, and a shoe shine, buy a cigar, or head into the room with the pool tables for a quick game. (Courtesy Bozarth Photography.)

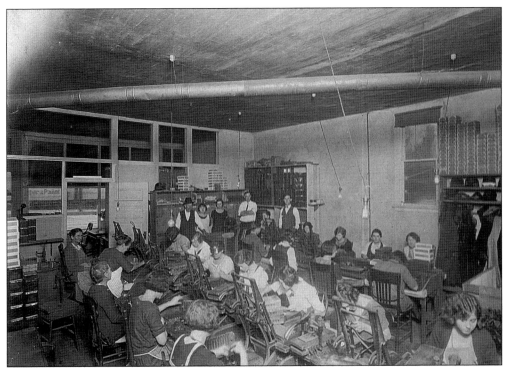

At Work in a Cigar Factory. Guthrie had a cigar factory that supplied the cigars sold at the Old Coin Barber Shop. Here is a picture of the factory founded in 1889 by Adam Traband (see chapter four for the car owned by Adam's son Phil and chapter six for his daughter-in-law Tressa Traband). (Courtesy Oklahoma Territorial Museum.)

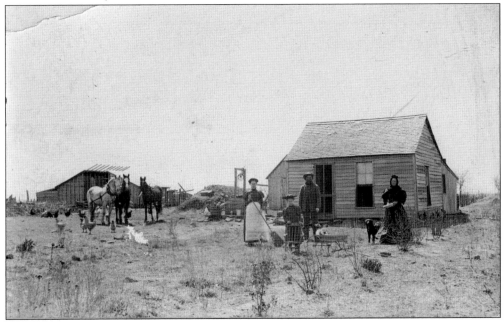

The Home on a Farm. Most families lived on farms. This photograph is of the Mock-Kendrick-Quier family's homestead near Crescent. (Courtesy Oklahoma Territorial Museum.)

A SMALL FARMHOUSE. Some farms were very simple. Pictured is the home of Mattie Graham Haver in eastern Logan County. (Author's collection.)

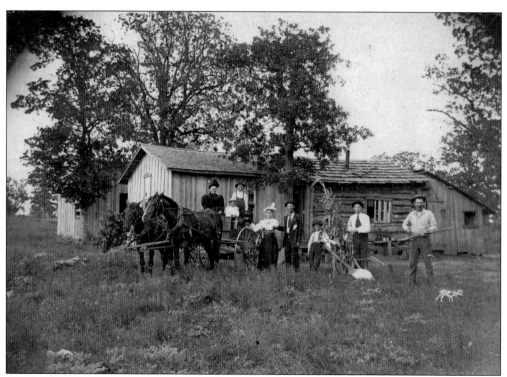

A LARGER FARMHOUSE. The log section of this house was the first house built in Seward, Oklahoma. Included in this picture are Annie Cooper (mother), Jim (seated), Joe (standing up on spring wagon), Alice Arthur, George (by the plow), and Frank (with .30-30 rifle). (Courtesy Oklahoma Territorial Museum.)

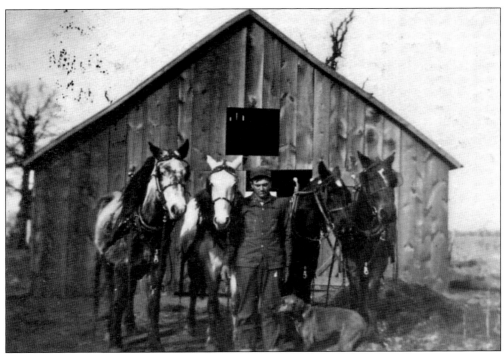

A Young Man with Horses and a Dog. This unidentified man with the two teams of horses lived near Crescent, Oklahoma. (Author's collection.)

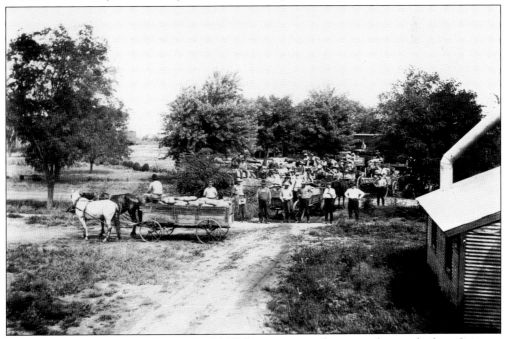

Wagons of Watermelons. Farmers would fill their wagons with watermelons and ride to Crescent to sell the fruit. This picture captures such a scene. The man second from the right in the front row is Mr. McGaffney; the others are unidentified. (Courtesy Archives Division, Oklahoma Historical Society.)

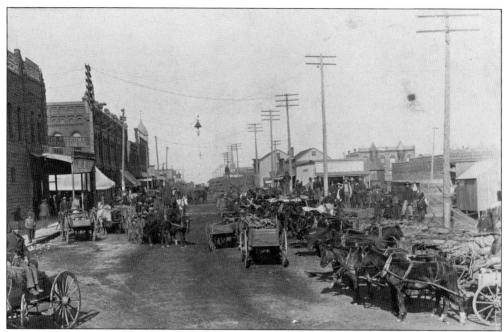

THE WOOD MARKET. Wood was still burned for heat and used for cooking in many stoves. Shown here in 1890 is the Guthrie Wood Market in 1890. (Courtesy Archives Division, Oklahoma Historical Society.)

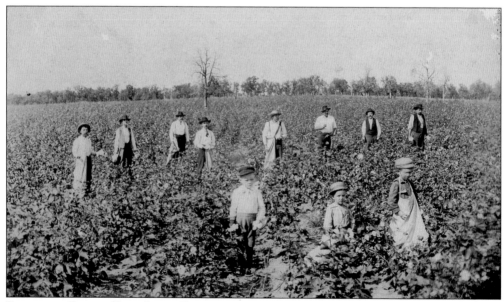

POSING IN A COTTON FIELD. Logan County was a major cotton producer in its early days. The cotton field of the Haver family in far eastern Logan County is pictured here. (Author's collection.)

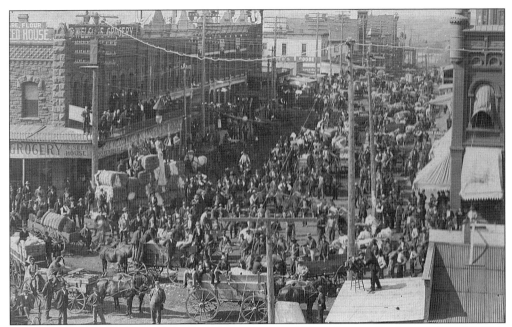

The Cotton Market in Guthrie. The cotton would be taken to Guthrie to be sold. This picture is of Cotton Day in Guthrie on October 13, 1896, on West Harrison Avenue. (Courtesy Oklahoma Territorial Museum.)

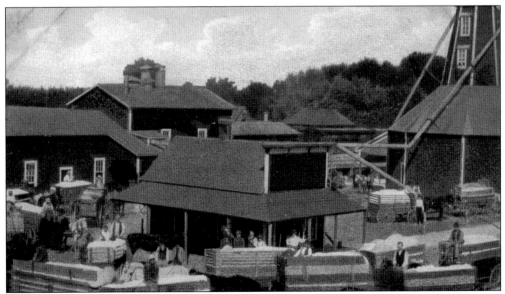

A Busy Cotton Gin, c. 1900. Most towns had a cotton gin. Here is one that was located in Guthrie. (Courtesy John Stanbro.)

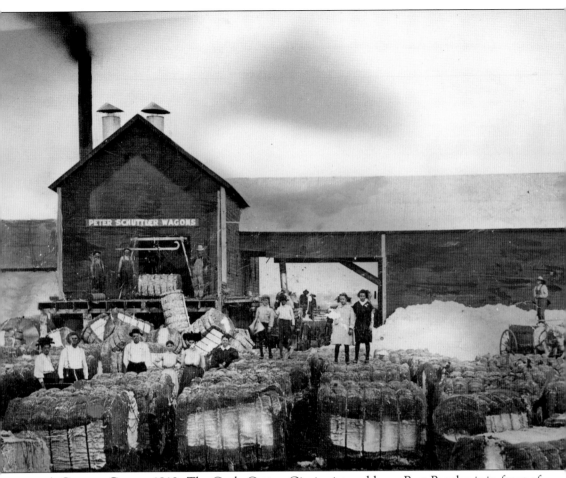

A COTTON GIN, C. 1912. The Coyle Cotton Gin is pictured here. Bert Bentley is in front of the scales in the middle of the platform with the cotton bale on it; the others are unidentified. (Courtesy Western History Collections, University of Oklahoma.)

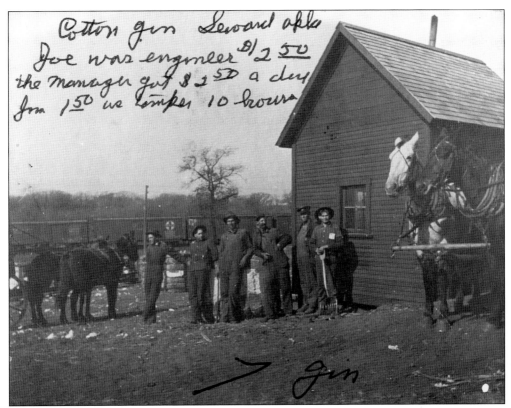

A Small Cotton Gin with a Horse Team. This is the cotton gin in Seward. The photograph label says that "Jim" was the engineer at the gin, and an arrow identifies him as the last man on the right. (Courtesy Oklahoma Territorial Museum.)

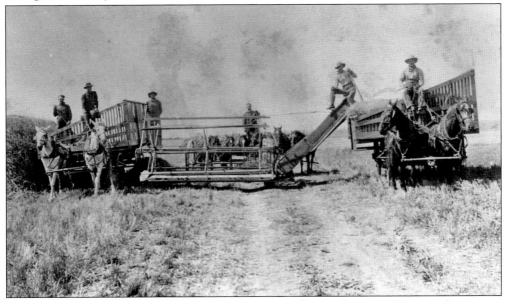

A Wheat Harvest Under Way. The western portion of Logan County was a center for growing wheat. (Courtesy Bozarth Photography.)

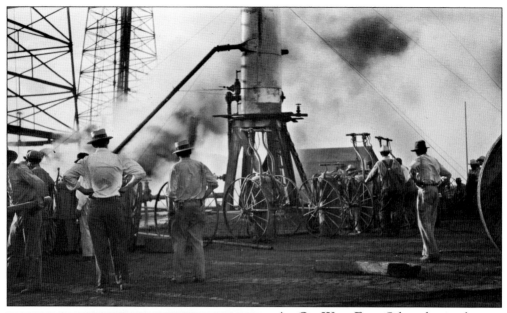

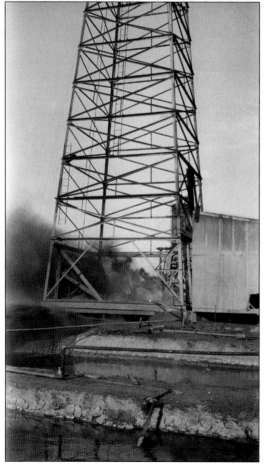

AN OIL WELL FIRE. Oil production began in northwestern Logan County around 1912. A small but intense field grew near Marshall, causing the boomtown of Roxana to spring up. This is a picture from the 1930s of an oil well fire near Marshall. (Courtesy Archives Division, Oklahoma Historical Society.)

A DIFFERENT ANGLE OF THE OIL WELL FIRE. This is another picture of the same oil well fire, with black smoke rising. (Courtesy Archives Division, Oklahoma Historical Society.)

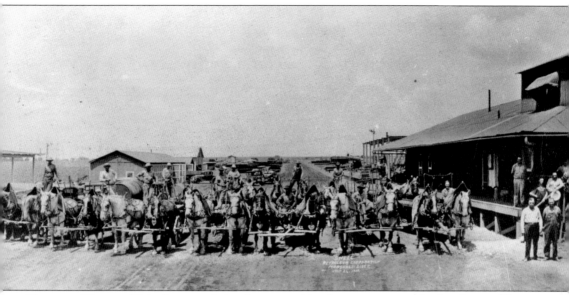

TEAMS OF HORSES. This photograph is of a competition between teams of oil well men. The competition was held by Shell Oil in the Marshall District on July 26, 1929. (Courtesy Western History Collections, University of Oklahoma.)

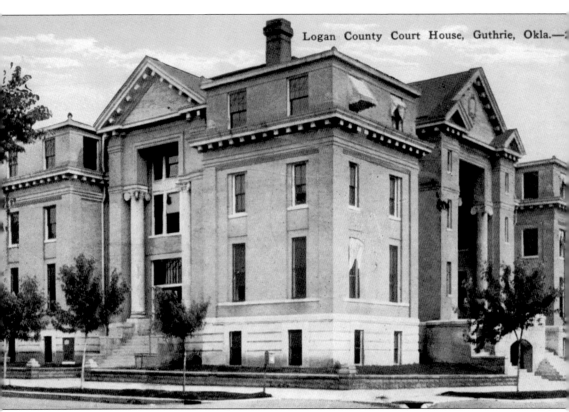

THE COURTHOUSE BUILDING. This photograph is of the building that is now the Logan County Courthouse. Constructed in 1907, it was originally called the State House because Governor Haskell had his offices there until the legislature built a permanent capitol. (Author's collection.)

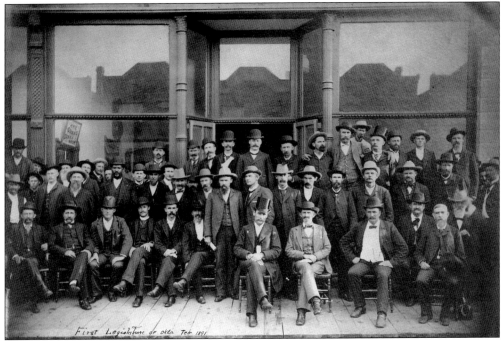

A GROUP OF MEN IN FRONT OF A WINDOW. Since Guthrie was the territorial capital, the legislature met there. Posing in front of the Grand Hotel in 1891 is the first legislature. In territorial times, the lower house was the Territorial House of Representatives and the upper house was the Territorial Council. (Courtesy Archives Division, Oklahoma Historical Society.)

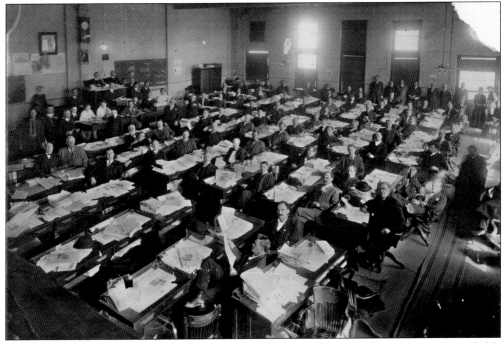

THE LEGISLATURE. This photograph shows the Oklahoma House of Representatives, probably after statehood in 1907 or 1908. (Courtesy Archives Division, Oklahoma Historical Society.)

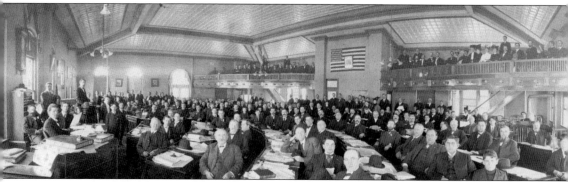

THE CONSTITUTIONAL CONVENTION POSES. This is a photograph of the convention that met in Guthrie in 1906 and 1907 to draw up the constitution of the State of Oklahoma. The man standing at the podium to the far left is William H. "Alfalfa Bill" Murray, one of the most important men in early Oklahoma history. Of the convention of 111 men, 99 were Democrats and 12 were Republicans. The Republicans were nicknamed the "Twelve Apostles." (Courtesy Archives Division, Oklahoma Historical Society.)

Four

TRANSPORTATION

Guthrie lies on a main north/south trunk of the Atchison, Topeka and Santa Fe Railroad (the Santa Fe). Built in 1887, the railroad was in the area before there was a town. Soon, Guthrie had seven different railroads with over 40 trains a day coming through. Because train depots were often one of the main gathering spots in small towns, many images of them have survived.

The golden era of Guthrie took place during the transition between the dominance of the horse and the dominance of the automobile. Several images in this chapter illustrate this change. People are shown going to Mineral Springs Park in a horse and buggy, and not too many years later people are shown traveling there in cars. In one picture, Dr. W.C. Graham of far-eastern Logan County proudly poses with his horse and buggy, and in another Phil Traband of Guthrie proudly poses in the family's new car.

Guthrie's citizens were anxious to have a streetcar system, and streetcars soon became an important part of everyday life in Guthrie. Early residents of the town employed yet another mode of transportation, the flat-bottomed boat.

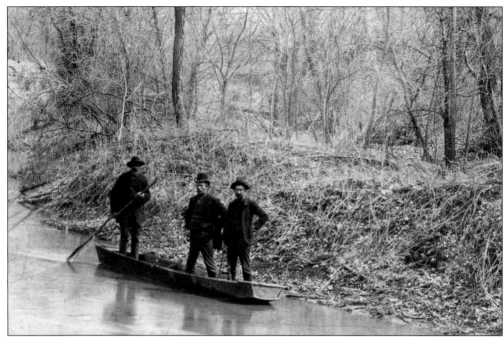

THREE MEN IN A BOAT. Early settlers were nothing if not inventive when attacking the problem of getting from here to there. This photograph shows an African American man ferrying two men, probably on Cottonwood Creek. (Courtesy Archives Division, Oklahoma Historical Society.)

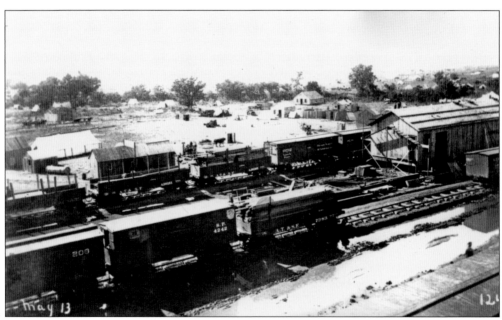

A RAILROAD YARD IN GUTHRIE. The railroad was naturally the way most people got around and received goods from other areas. Guthrie lay on the Santa Fe Railroad and became the hub for several other branch railroads. Pictured is the rail yard right after a run delivering lumber and other material for the fast-growing town of Guthrie. (Courtesy Archives Division, Oklahoma Historical Society.)

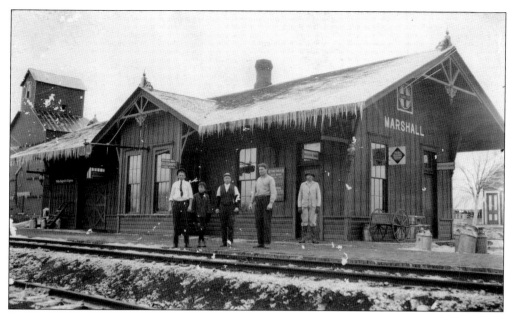

A Depot in Marshall. The railroad depot was the center of commerce at all times of year. Pictured here in winter, sometime between 1910 and 1918, is the depot at Marshall on the Santa Fe Railroad. (Courtesy Archives Division, Oklahoma Historical Society.)

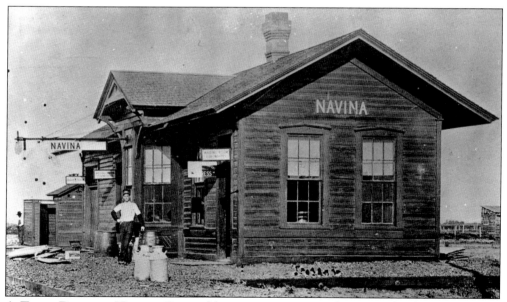

A Train Depot in Navina. Pictured here, sometime around 1904, is the depot at Navina. (Courtesy Western History Collections, University of Oklahoma.)

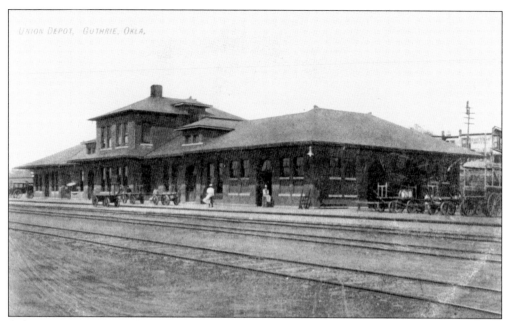

A DEPOT IN GUTHRIE. The Union Depot in Guthrie was built by the Santa Fe Railroad in 1903 and served over seven different railroad lines with up to 40 passenger trains a day. Fortunately, this building exists today and might one day be a railroad depot again if passenger trains are restored to Guthrie. (Courtesy Archives Division, Oklahoma Historical Society.)

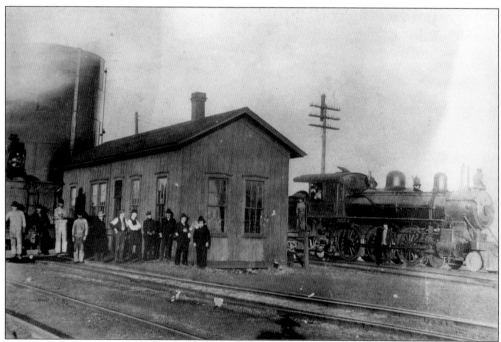

A SMALLER DEPOT. This is a photograph of the south yard in Guthrie. This building actually survived until recently as a retail store; it still stands unused. (Courtesy Archives Division, Oklahoma Historical Society.)

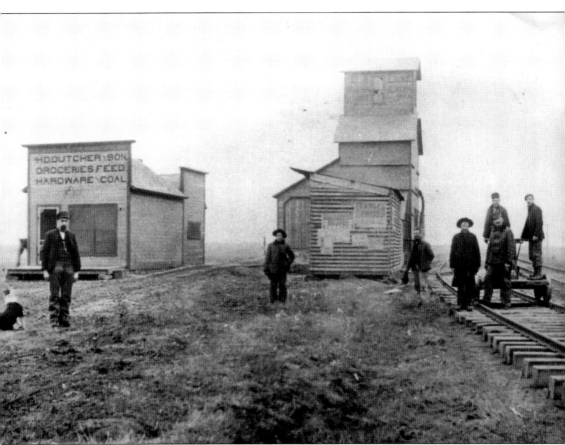

THE TOWN OF DUTCHER. Some towns were never much more than a whistle stop on the railroad. Pictured is the town of Dutcher in southwestern Logan County, which is on the railroad line from Guthrie to El Reno. In this 1910 image, Henry D. Dutcher is shown on the far left, and on the handcar are his sons George (left) and Albert; the other men are unidentified. (Courtesy Bill Ward.)

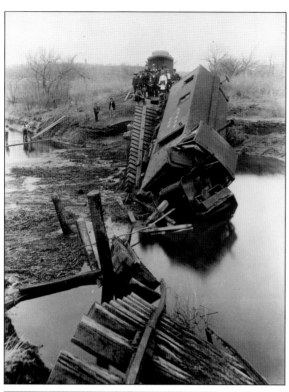

A Railroad Wreck. Floods often undermined the railroad bridges. This photograph was most likely taken on the Cimarron River Bridge of the Santa Fe Railroad. (Courtesy Bozarth Photography.)

Repairing a Railroad Bridge. Crews are repairing a railroad bridge in the aftermath of a train wreck near Goodnight, Oklahoma, where Logan, Lincoln, and Payne Counties come together. The date is March 19, 1909. (Courtesy Oklahoma Territorial Museum.)

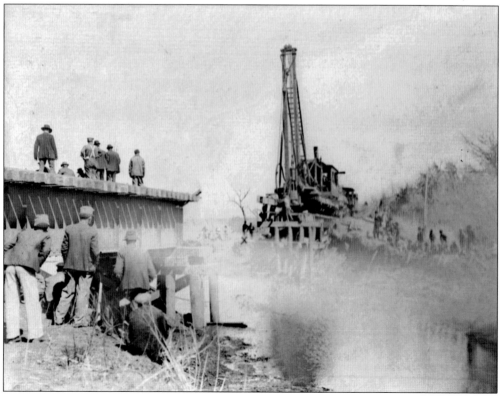

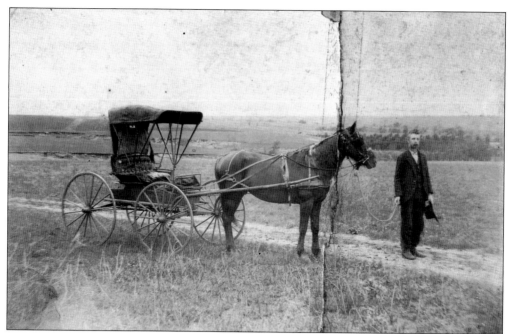

A Man with a Horse and Buggy in the Countryside. Guthrie and Logan County grew during a time of transition in transportation. Shown are Dr. W.C. Graham and his horse and buggy in far eastern Logan County in the late 1890s. (Author's collection.)

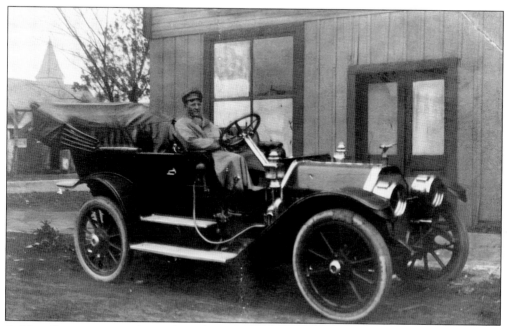

A Man Sitting in an Auto. Less then 20 years later, people were trying out their favorite automobiles. Pictured is Phil Traband, son of cigar factory owner Adam Traband, in his new car. (Courtesy Archives Division, Oklahoma Historical Society.)

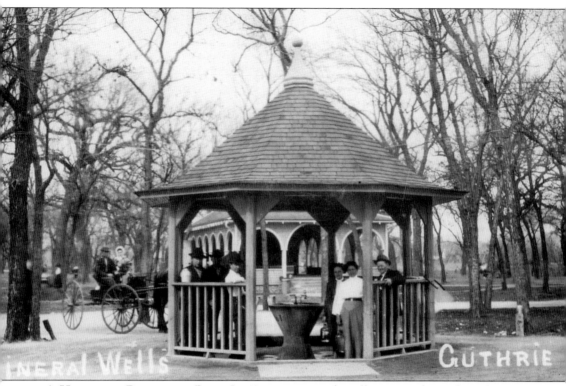

A Horse and Buggy in a Park. In 1911, most people still went to the park in their horse and buggy. A horse and buggy and park visitors are pictured at Mineral Wells Park in Guthrie. (Author's collection.)

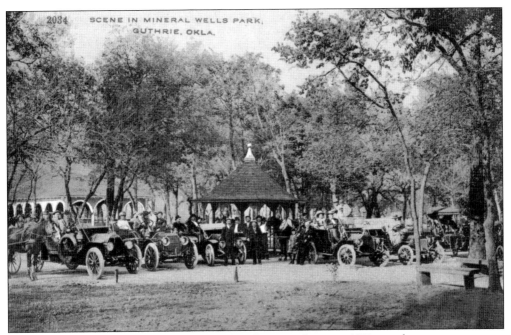

Cars Pose at Mineral Wells Park. Only a few years later, in 1913, nearly everyone went to the park in their automobiles. (Courtesy John Stanbro.)

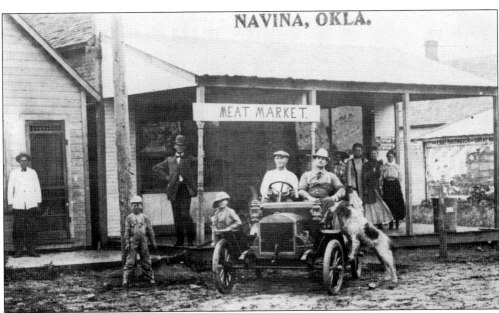

A Car on Display in Front of a Meat Market. A new car generated much excitement, especially in the small town of Navina. (Courtesy Postcard Collection, 1976.023, Department of Special Collections and University Archives, McFarlin Library, University of Tulsa.)

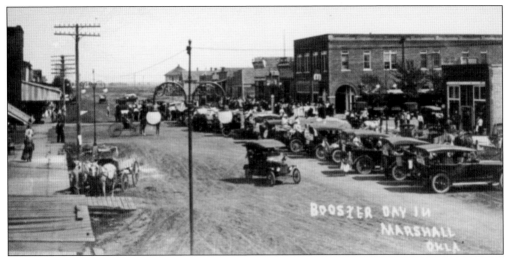

CARS ON MAIN STREET. Cars would soon be featured in almost all the major activities in these towns. This image was taken on Booster Day in Marshall. A lone horse-drawn wagon on the left side of Main Street can still be seen. (Courtesy Cherokee Strip Regional Heritage Center.)

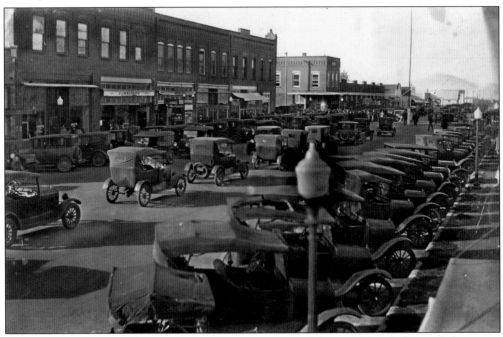

CARS FILLING MAIN STREET, c. 1920. Soon, the automobile would be choking all the major towns in Logan County. Here is some early congestion on Main Street in Marshall. (Courtesy Archives Division, Oklahoma Historical Society.)

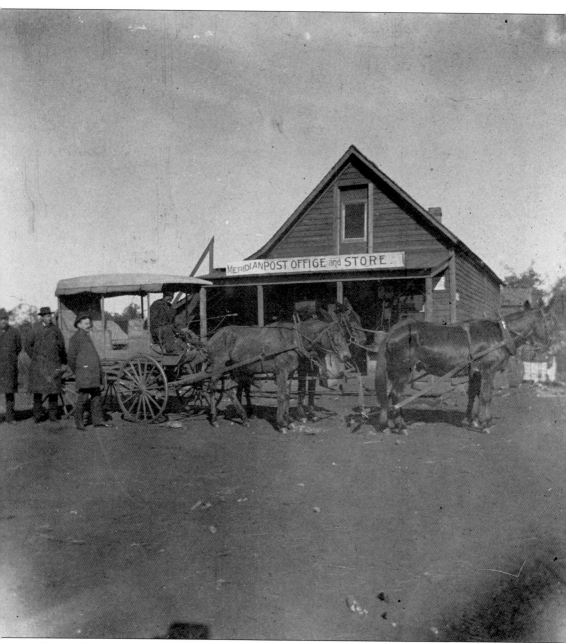

A Horse-Drawn Cart in front of a Small Store. A horse-drawn mail cart is shown in front of a store in Meridian around 1902. (Courtesy Archives Division, Oklahoma Historical Society.)

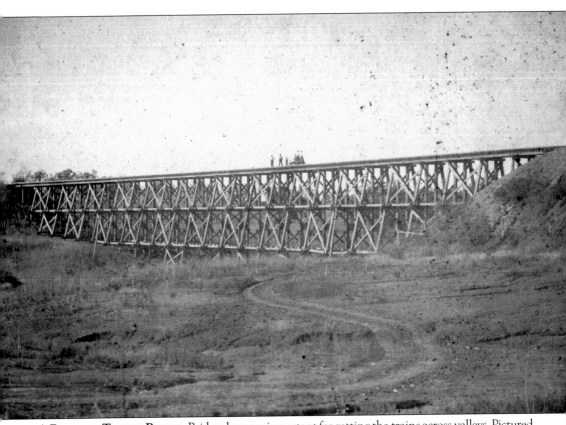

A Railroad Trestle Bridge. Bridges became important for getting the trains across valleys. Pictured is a wooden trestle bridge across a valley in far-eastern Logan County. (Author's collection.)

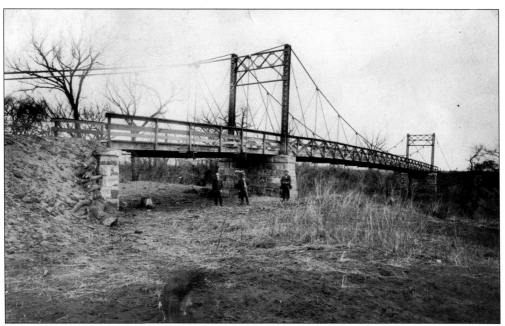

A SUSPENSION BRIDGE. This is the bridge over Skeleton Creek, north of Guthrie. (Courtesy Oklahoma Territorial Museum.)

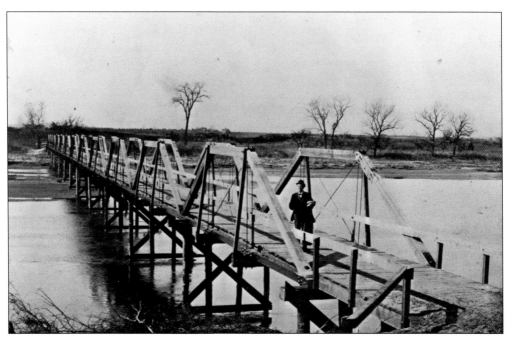

A MAN WALKING ON A BRIDGE. This is the first bridge across the Cimarron River, which was north of Pleasant Valley. Jerome Blair is walking on the bridge, which replaced a nearby ford that had been used by settlers. (Courtesy Western History Collections, University of Oklahoma.)

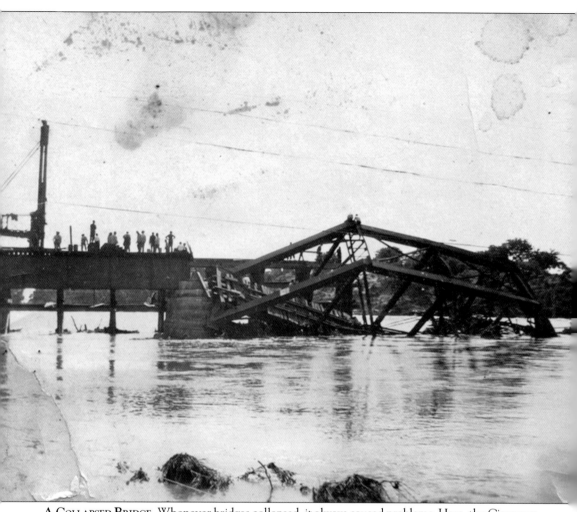

A COLLAPSED BRIDGE. Whenever bridges collapsed, it always caused problems. Here, the Cimarron River is flooded and parts of the supports have been washed away. (Courtesy Western History Collections, University of Oklahoma.)

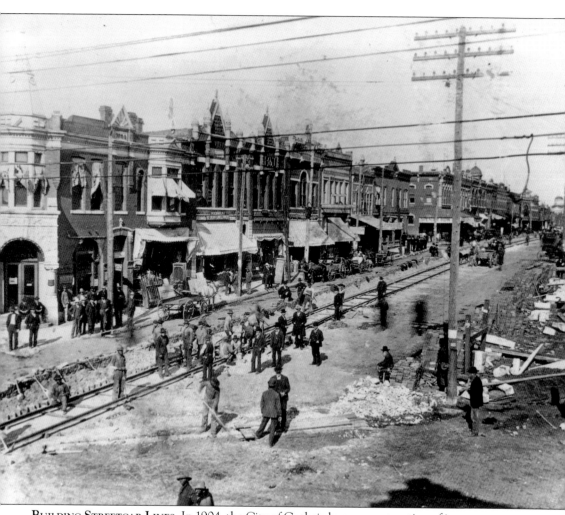

BUILDING STREETCAR LINES. In 1904, the City of Guthrie began construction of its new streetcar line. (Courtesy Bozarth Photography.)

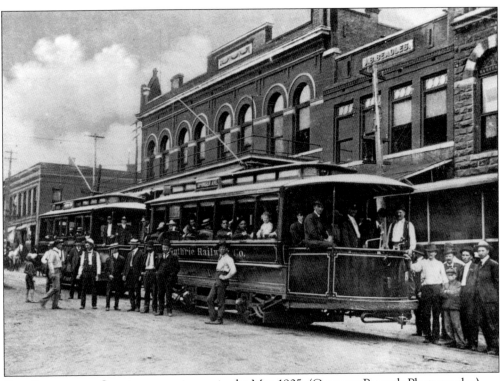

Two Streetcars. Streetcars were in service by May 1905. (Courtesy Bozarth Photography.)

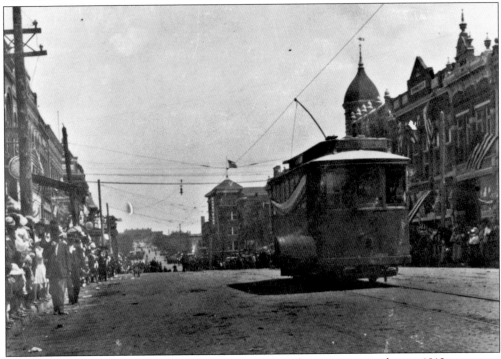

A Streetcar in the Middle of the Road. By the time this picture was taken in 1912, streetcars were an accepted part of everyday life in Guthrie. (Courtesy Oklahoma Territorial Museum.)

Five

CHURCHES AND SCHOOLS

Early settlers were divided regarding the need to worship God as they saw fit and the need to educate their children. Both needs were met very early in Guthrie and Logan County.

The early Presbyterians in Guthrie worshipped in a tent, though they were anxious to get out of it and into a frame church to be succeeded as quickly as possible by a brick or stone structure, preferably with a spire and a bell tower (see page 82). Presbyterian, Baptist, Methodist, Christian (Disciples of Christ), and Episcopal churches were all built on Noble Avenue, still known as "Church Row."

The Catholic Church quickly made its presence felt, erecting not just a church but also a school. The school, St. Joseph's Academy, was founded by Benedictine Sisters and was, for many years, a landmark on the southwest side of town.

Provisions were made for a country school to be built every three miles, but towns naturally wanted their own schools. Guthrie, being the center of Logan County as well as the Oklahoma Territory, built several schools, including the Logan County High School.

The Capital City Business College was an important feature of Guthrie life. Founded in 1889, it only closed during the days of the Great Depression.

Guthrie's attempt at a city college was not a success. However, Oklahoma Methodist University moved to Oklahoma City and became Oklahoma City University.

Many churches and schools remain from this period, which is a testimony to the efforts of the early settlers of Guthrie and Logan County.

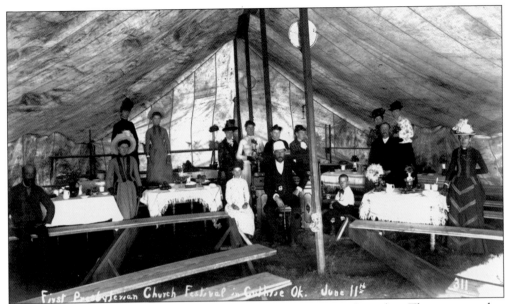

A Church Event in a Tent. Churches were very important to early settlers. They attempted to have worship services and other church events as quickly as possible after the land run. Pictured are the women of the First Presbyterian Church of Guthrie holding a festival on June 11, 1889. (Courtesy Archives Division, Oklahoma Historical Society.)

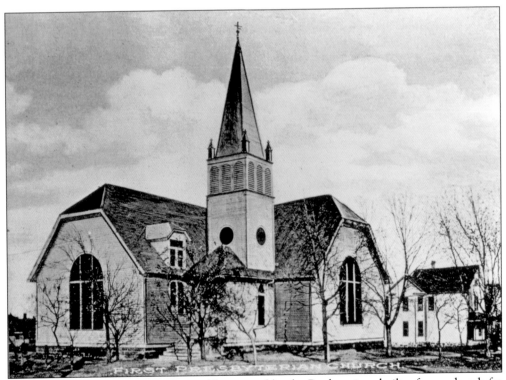

First Presbyterian Church. As quickly as possible, the Presbyterians built a frame church for worship on Noble Avenue in 1891. (Courtesy Bozarth Photography.)

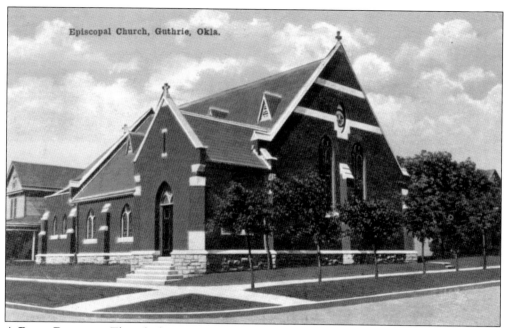

A BRICK BUILDING. Though the Episcopalians first had a frame church, they quickly replaced it with this brick building that still stands on Noble Avenue today. (Courtesy Archives Division, Oklahoma Historical Society.)

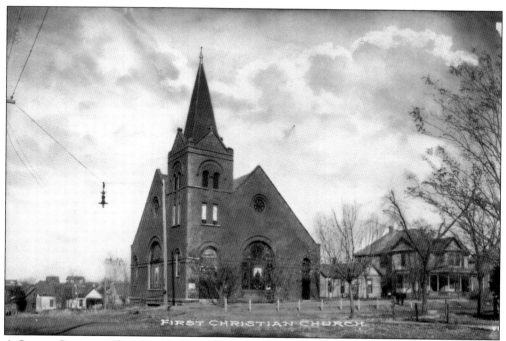

A SPIRED CHURCH. The First Christian Church (Disciples of Christ) built a church with a spire on Noble Avenue. (Courtesy Archives Division, Oklahoma Historical Society.)

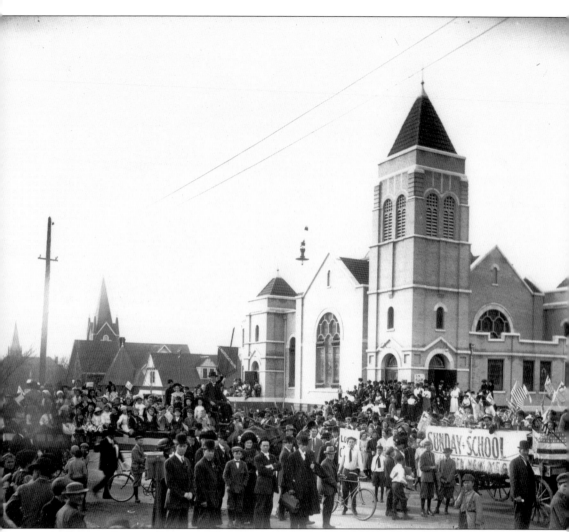

A Sunday School Parade. This photograph is of a Sunday school parade in front of the Methodist church, which was built in 1910 at Noble Avenue and Broad Street. Other churches are visible down the street. Church Row is one of the distinctive features of Guthrie to this day. (Courtesy Bozarth Photography.)

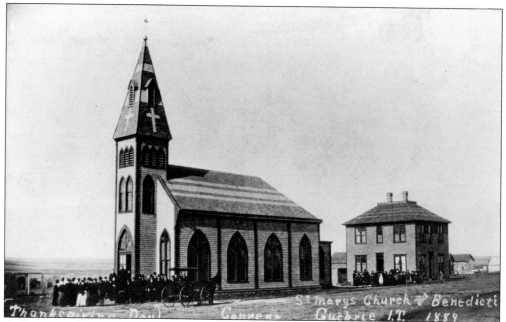

A Catholic Church. The Catholics built a nice church as well. This is a photograph of St. Mary's Church and the Benedictine School during a Thanksgiving festival in 1889. (Courtesy Bozarth Photography.)

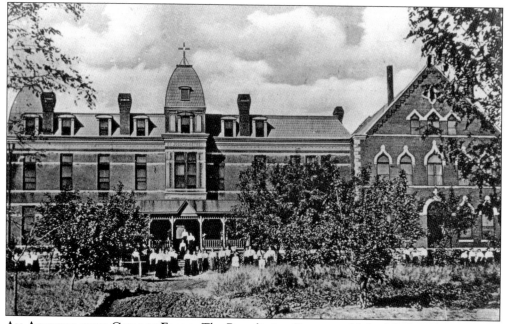

An Academy with Girls in Front. The Benedictine Sisters established St. Joseph's Academy in 1892. This picture was taken about 1899. At that time, the academy operated as a boarding school for girls as well as a day school. It became Benedictine Heights College in 1948 and became coeducational in 1950. It continued in Guthrie until 1962, when it moved to Tulsa and became Monte Cassino School. (Courtesy Bozarth Photography.)

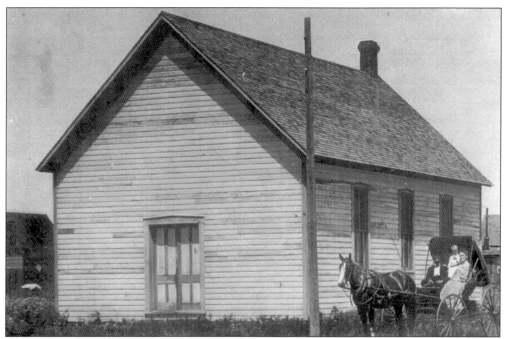

A SMALL-TOWN CHURCH. Small towns also sponsored churches. This is a photograph of the First German Evangelical Church in Marshall, Oklahoma. It was built between 1903 and 1904. Some of the men who constructed the church were Henry Grossman, William Bainhorn, Gustav Burchardt, Julius Diedrich, S.H. Jansen, Albert Kohls, Herman Diedrich, and Paul Burchardt. (Courtesy Bill Diedrich.)

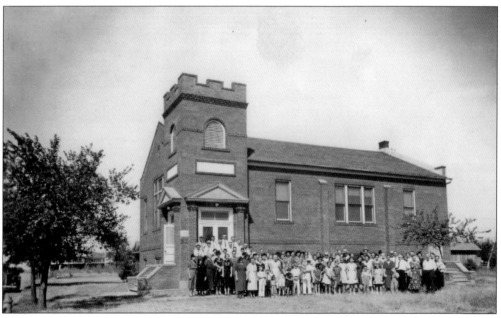

A BRICK CHURCH WITH A TOWER. In 1926, the congregation built a new building that still stands as St. Paul's United Church of Christ. This was the home church of famous Oklahoma historian Angie Debo, who can be seen in chapter six. (Courtesy Bill Diedrich.)

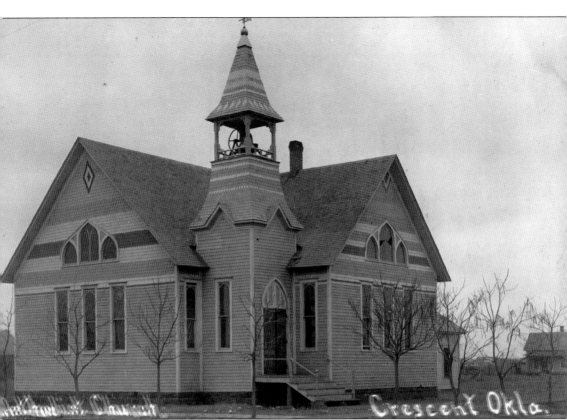

A FRAME CHURCH WITH BELL TOWER. This is the First Methodist Church of Crescent, which was built in 1905. (Courtesy Oklahoma Territorial Museum.)

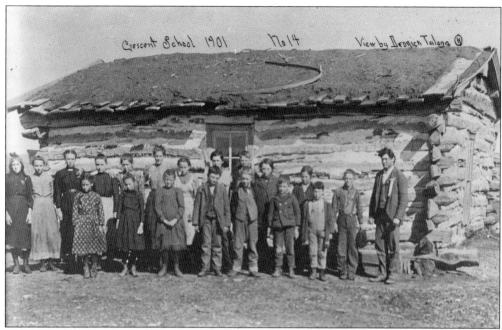

A Country School. Early schools were also very important to settlers. School No. 14 in Crescent is pictured in the early days. (Courtesy Archives Division, Oklahoma Historical Society.)

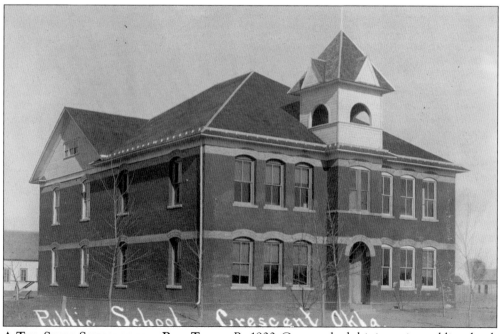

A Two-Story School with a Bell Tower. By 1900, Crescent had this imposing public school. (Courtesy Oklahoma Territorial Museum.)

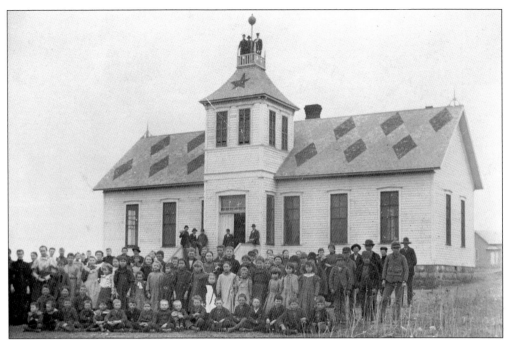

A School with Diamonds on its Roof. The public school of Orlando was very impressive. It had a diamond pattern on the roof and a star on the bell tower. (Courtesy Western History Collections, University of Oklahoma.)

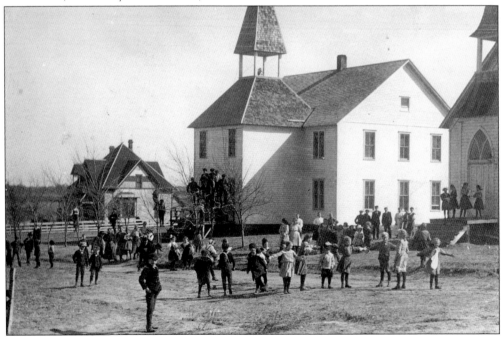

A School with Children Playing. The public school in Coyle, Oklahoma, is pictured. This is probably the schoolhouse that was built in 1903 and sat next to the Baptist church. The children look like they are getting ready to play a game of "crack the whip." (Courtesy Western History Collections, University of Oklahoma.)

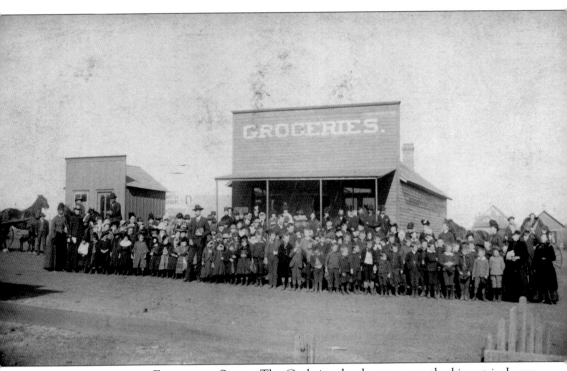

Schoolchildren in Front of a Store. The Guthrie school system was the biggest in Logan County, and at first classes met in various buildings downtown. Pictured around 1889 or 1890 are Guthrie teachers and students. (Courtesy, Archives Division, Oklahoma Historical Society.)

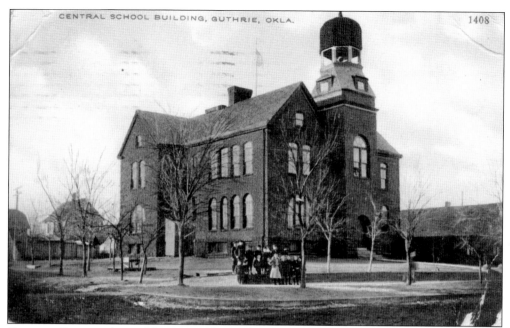

CENTRAL SCHOOL. As quickly as possible, Guthrie built a sturdy school building called Central School. From 1894 to 1904, high school classes were held on the third floor of the original Central School, which stood at the corner of Noble Avenue and Ash Street. (Courtesy John Stanbro.)

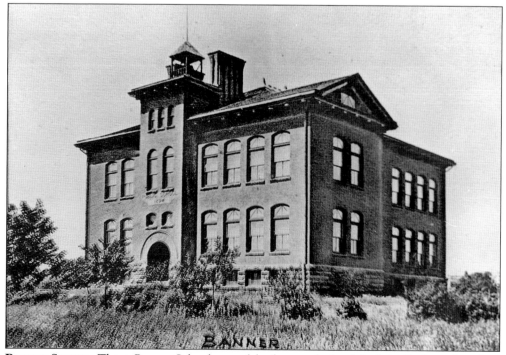

BANNER SCHOOL. This is Banner School, one of the four ward schools built in Guthrie; the others were Central, Lincoln, and Capital. The schools were constructed with the help of a bond issue passed by the people of Guthrie in May 1893. (Courtesy Bozarth Photography.)

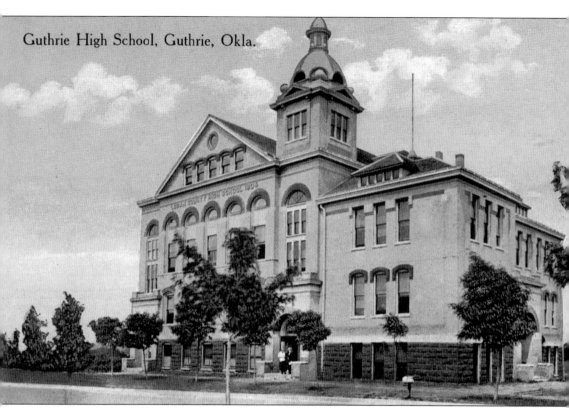

Guthrie High School, Guthrie, Okla.

LOGAN COUNTY HIGH SCHOOL. This is a photograph of the Logan County High School, built in 1904. It served students from all over Logan County and also was the location for the Teachers Institute for Guthrie in 1905 and 1906. (Author's collection.)

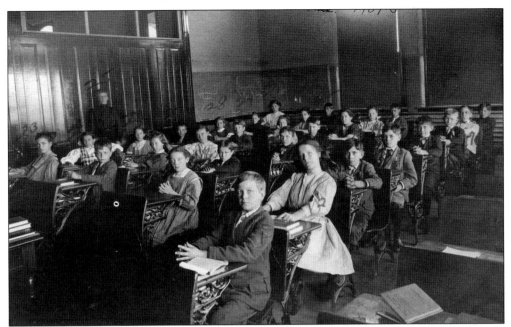

THE INTERIOR OF A SCHOOL ROOM. This is a shot from the 1907–1908 school year of a fifth-grade class in Guthrie. (Courtesy Archives Division, Oklahoma Historical Society.)

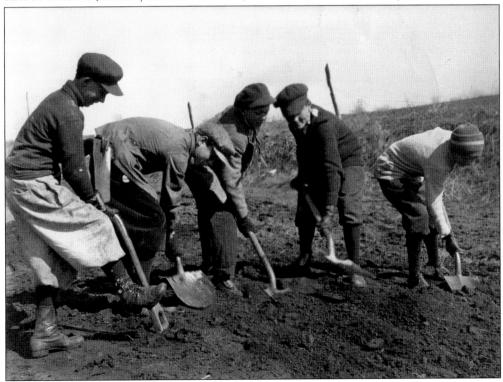

SCHOOLCHILDREN WITH SHOVELS. This picture is labeled "Guthrie High School Students at Work," but the students are smiling, making one wonder if the picture was staged. (Courtesy Archives Division, Oklahoma Historical Society.)

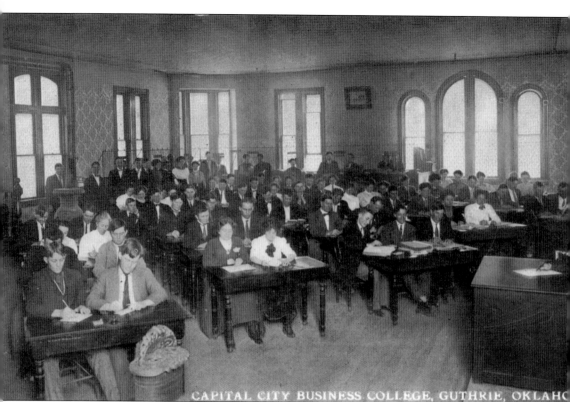

CAPITAL CITY BUSINESS COLLEGE, GUTHRIE, OKLAHO

THE INTERIOR OF AN ADULT CLASS. Starting in 1889, Guthrie boasted the Capital City Business College, originally at the corner of Cleveland and Division Streets. Later, it was moved to the building that originally housed the *State Capital* newspaper offices. Pictured is an interior photograph of one of the classes. (Courtesy Archives Division, Oklahoma Historical Society.)

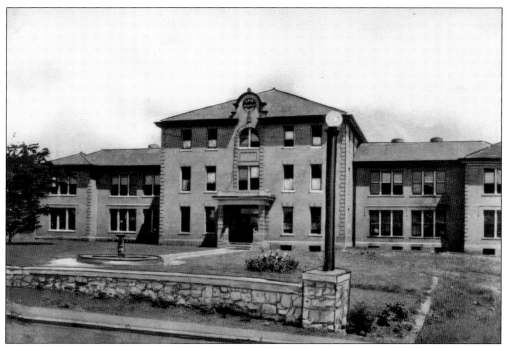

THE ADMINISTRATION BUILDING. This photograph shows the administration building at Langston University, a traditionally African American school, sometime before 1929. (Courtesy Archives Division, Oklahoma Historical Society.)

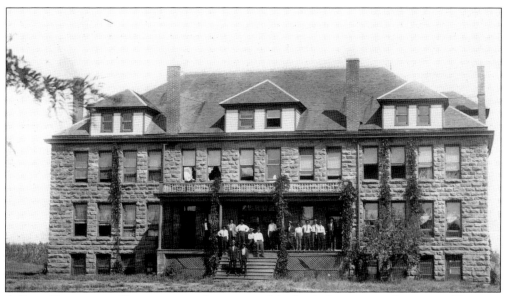

A BOYS DORMITORY. Shown is an early picture of the boy's dormitory at Langston. (Courtesy Archives Division, Oklahoma Historical Society.)

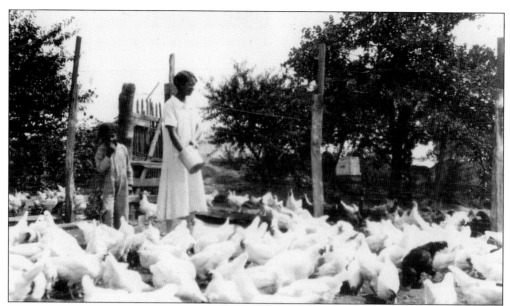

FEEDING THE CHICKENS. Here a lady and a curious child are handing out a meal to some chickens. (Courtesy Archives Division, Oklahoma Historical Society.)

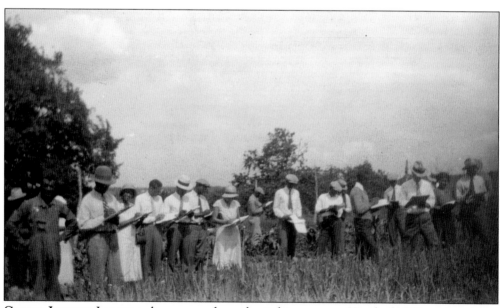

GARDEN JUDGING. Langston also sponsored a garden-judging contest. Here both African Americans and whites are participating in the competition. (Courtesy Archives Division, Oklahoma Historical Society.)

Six

PEOPLE

Guthrie being the capital of Oklahoma Territory and then the state of Oklahoma State attracted many important people. Carrie Nation came here for a time to carry out her crusade against the evils of alcohol. Politicians came here, as well. At first they came for the territorial legislature, then the constitutional convention, and then for the state legislature.

African Americans came to Guthrie seeking to start a new life and hoping, against experience, to find a land without prejudice. The Iowa Indians came to see the new civilization that was quickly sweeping away their way of life.

On the whole, the story of Guthrie and Logan County is of ordinary men and women living their lives in a new land.

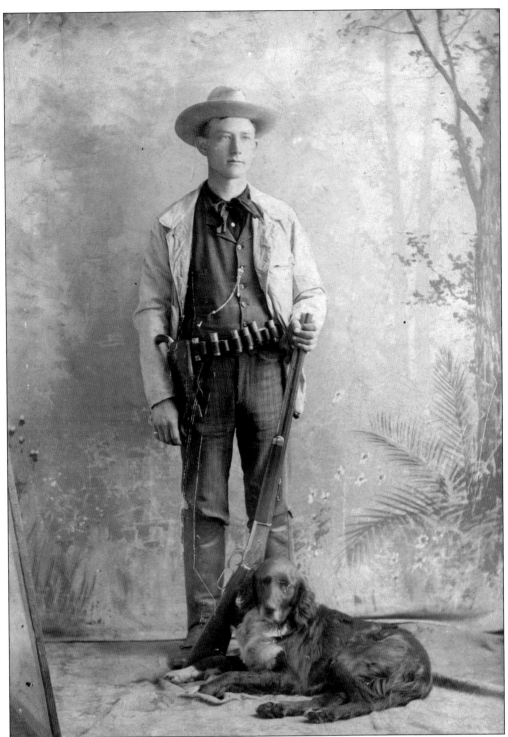

A MAN WITH HIS DOG. Many images of the people of Guthrie and Logan County have been preserved; sometimes, that is all people have. Shown here are Jerre Salmon and his faithful dog. (Courtesy Archives Division, Oklahoma Historical Society.)

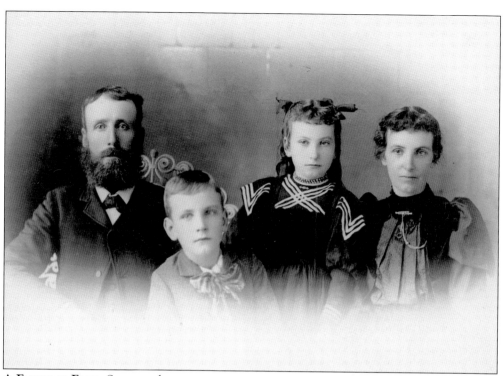

A FAMILY OF FOUR. Some, such as Angie Debo, have made a name for themselves. Shown in this family portrait are, from left to right, Edward (Angie's father), Edwin (her brother), Angie, and Lina (Angie's mother). Angie (1890–1988) was one of the premiere historians of Oklahoma. She had a long career and specialized in books on the relationships between Europeans and Native Americans. (Courtesy Special Collections, Edmond Low Library, Oklahoma State University.)

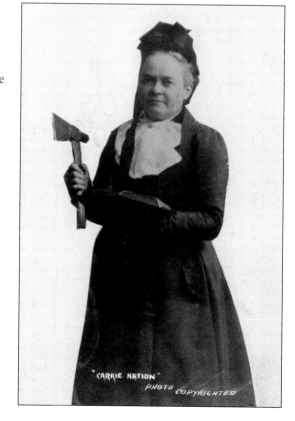

NATION WITH THE HATCHET. Some, such as Carrie Nation, spent only a brief time in Guthrie. Pictured is Carrie with her hatchet. Guthrie was the perfect town for Carrie and her efforts to end the evils of alcohol. (Courtesy Archives, Division, Oklahoma Historical Society.)

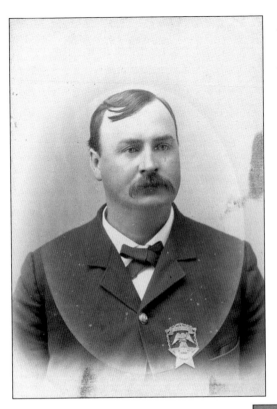

A Man with a Badge. Some men made it their life's work to keep the peace in Guthrie. Pictured is a city marshal from the early days. (Courtesy Archives Division, Oklahoma Historical Society.)

Asp in a Suit. Some men made a name for themselves in territorial politics. This is Henry Asp, who was the lawyer for the Oklahoma section of the Santa Fe Railroad. Though considered a good man in his personal life, he became notorious as a railroad lawyer. He was one of the 12 Republicans elected to the state constitutional convention. (Courtesy Archives Division, Oklahoma Historical Society.)

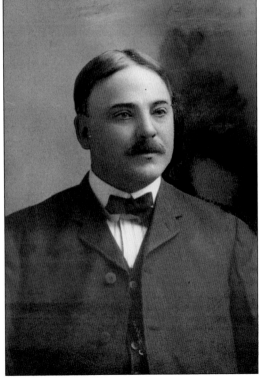

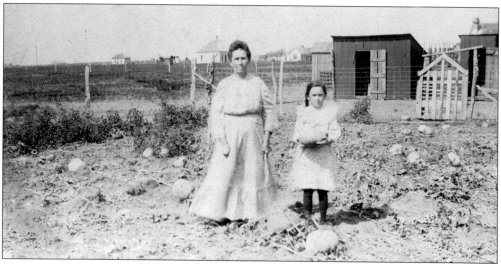

A Lady and a Girl in a Garden. Some residents lived quiet lives of which little has been preserved. Pictured in 1909 in their garden in the town of Lovell are Margaret Elizabeth Miller and her daughter Flossie. (Courtesy Archives Division, Oklahoma Historical Society.)

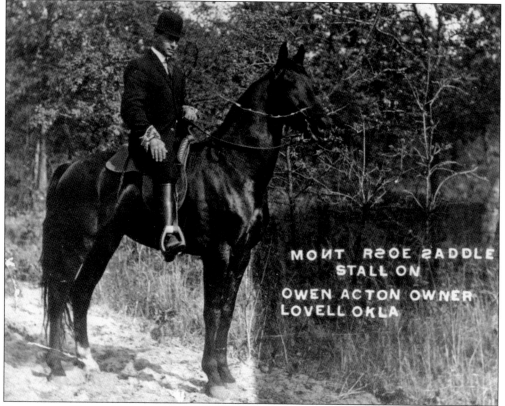

Posing on a Horse. This image is most likely of Owen E. Acton on his saddle stallion Mont Rose. Owen was the son of the man who founded the bank at Lovell. He was the first farm boy to graduate from the Logan County High School, and he later made a name for himself playing football at the University of Oklahoma. (Courtesy Archives Division, Oklahoma Historical Society.)

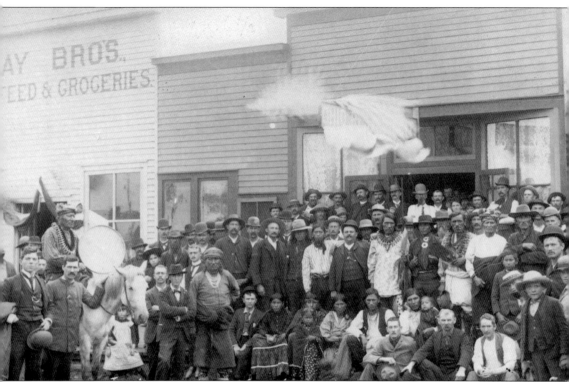

A Crowd in Front of a Store. Native Americans did not play as big a role in Guthrie as they did in towns like Kingfisher, but they did have a presence in early Guthrie. A portion of eastern Logan County had been part of the Iowa Reservation. Here are some Iowa Indians in front of Nowlan's Restaurant on September 16, 1889. The man to the left on horseback is Frank Kent; the woman seated second from the left is Emma Kent. (Courtesy Archives Division, Oklahoma Historical Society.)

E.P. McCabe. Pictured is E.P. McCabe (1850–1920), a two-time state auditor of Kansas, who came to Guthrie in 1890 and helped establish the township of Langston. Getting the territorial legislature to establish the Colored Agricultural and Normal College, now Langston University, was arguably his greatest achievement. (Courtesy Archives Division, Oklahoma Historical Society.)

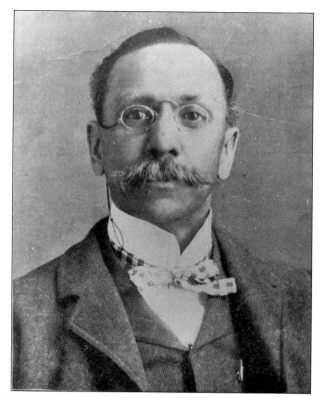

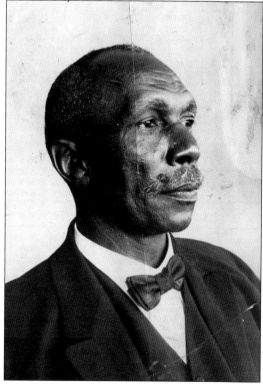

The First President of Langston. This photograph is of Inman E. Page (1853–1935), who was the first president of what is now Langston University. In 1877, he was one of the first two African Americans to graduate from Brown University. In 1898, he became president of the school at Langston and served for 17 years. (Courtesy Archives Division, Oklahoma Historical Society.)

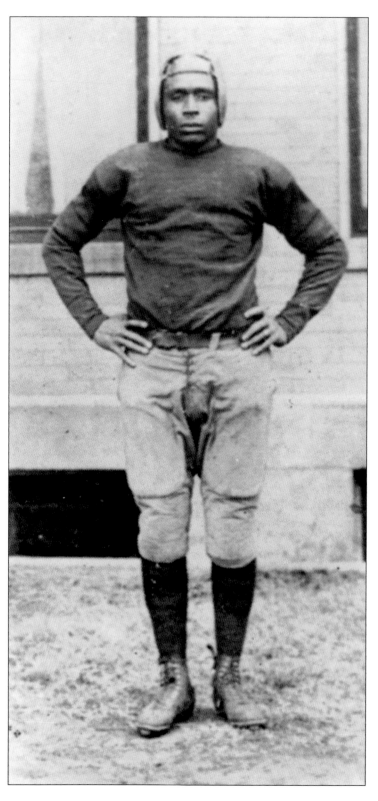

A Langston Student in a Football Uniform. Then, as now, football was a favorite sport with the people of Oklahoma. Pictured is Joe Johnston of Langston, part of the college's miracle team of 1924. (Courtesy Archives Division, Oklahoma Historical Society.)

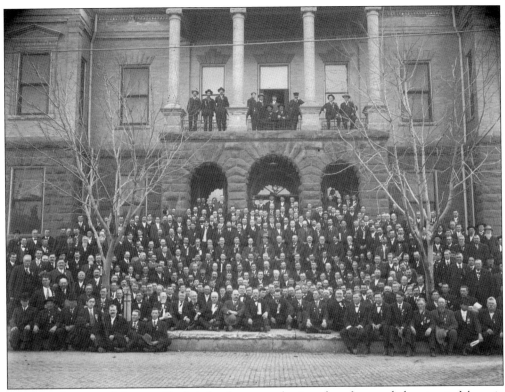

A Large Group of Masons. Guthrie has been a gathering place for men belonging to Masonic orders since the early days. This photograph of the Grand Lodge of the State of Oklahoma at Guthrie was taken during the session held from February 10 to 11, 1909. This was the first session after the union of Indian Territory and Oklahoma Territory, when Oklahoma had become a state. (Courtesy Archives Division, Oklahoma Historical Society.)

Early Teachers. Then, as now, teachers were important in Logan County. A group of teachers from the early days is pictured here. Unfortunately, only Louise M. Olney is identified; she is seated in the front on the left. (Courtesy Archives Division, Oklahoma Historical Society.)

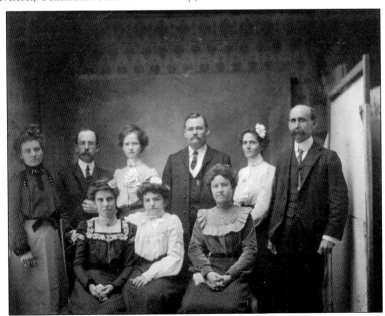

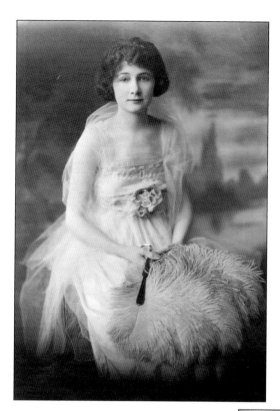

A LADY IN A GAUZE DRESS WITH A FAN. Many women became prominent in Guthrie society. Among them was Tressa Traband (1893–1986), the wife of Phil Traband. (Courtesy Archives Division, Oklahoma Historical Society.)

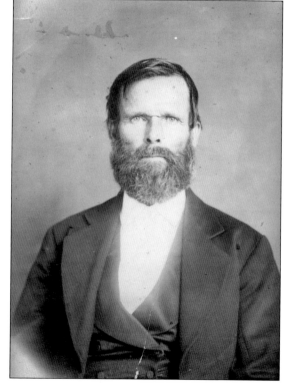

A MAN WITH A BEARD. Some people made their mark on Guthrie and on Logan County without having their names preserved for posterity. The man pictured here appears to have dressed up for this formal photograph. (Courtesy Archives Division, Oklahoma Historical Society.)

A BRIDAL COUPLE. Unfortunately, the names of this couple have not been preserved. They were photographed by Armantrout of Guthrie, but they might not have lived in the town. (Courtesy Archives Division, Oklahoma Historical Society.)

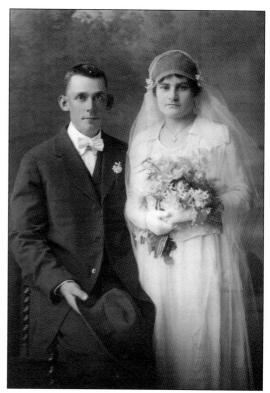

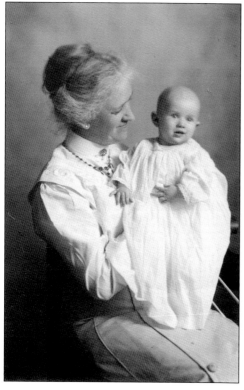

A LADY HOLDING A BABY. Courtey Van Voorhees of Guthrie is pictured here, probably around the beginning of the 20th century, but the baby is unidentified. (Courtesy Archives Division, Oklahoma Historical Society.)

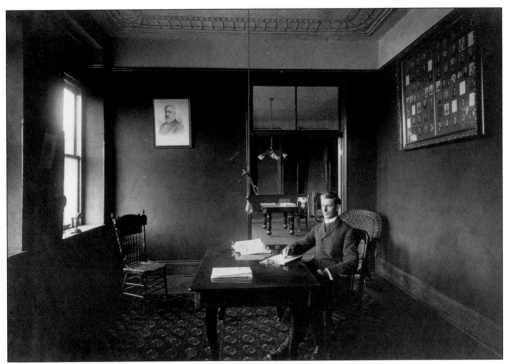

FRANK GREER AT A TABLE. Greer was the editor of the strongly Republican newspaper the *State Capital*. His feud with the man in the next picture had devastating consequences for Guthrie. (Courtesy Western History Collections, University of Oklahoma.)

HASKELL IN A FROCK COAT IN A CROWD. Shown is Charles Haskell on November 16, 1907, at his inauguration as the first governor of the new state of Oklahoma. Haskell was a Democrat, and his feud with the strongly Republican Frank Greer motivated Haskell to work to move the state capital from Guthrie to Oklahoma City. The move occurred after a statewide vote in 1910, and property values in Guthrie fell overnight by as much as 80 percent. (Courtesy Oklahoma Territorial Museum, Guthrie, Oklahoma.)

Seven

HAVING FUN

The men and women of Guthrie and Logan County worked hard but were always looking for ways to have fun and enjoy the lives they had made.

Baseball games were popular, and towns had rival adult teams that played one another. A baseball game took place in Guthrie very soon after the town had been settled. Horse racing was enjoyed then just as it is enjoyed today.

Because Guthrie lies on Cottonwood Creek, the people of the area were able to indulge in swimming and boating. The parks created by the settlers provided a place to get away from a life that in many ways was still very rough and demanding.

Picnics and formal balls, stage productions, and traveling theater troops all provided entertainment for the people of Logan County. Sometimes, as with the picture of the "nightcap party" in Seward (page 123), it is not quite known what was going on.

Guthrie has always been a city of parades. Starting with the very first Memorial Day Parade in 1889, these events have been important to the residents of Guthrie and of Logan County.

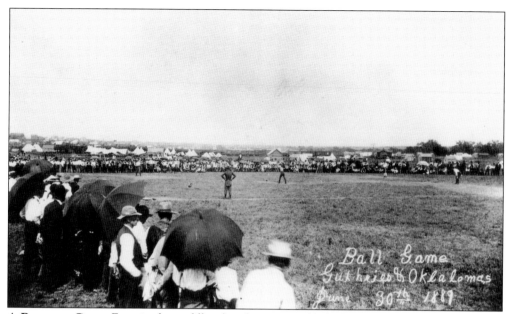

A BASEBALL GAME. Even in the middle of working to establish their lives, people took the time for what are now called leisure activities. This is a picture of a baseball game between Guthrie and probably Oklahoma City on June 30, 1889. In the background, it can be seen that Guthrie is still very much a tent city. (Courtesy Bozarth Photography.)

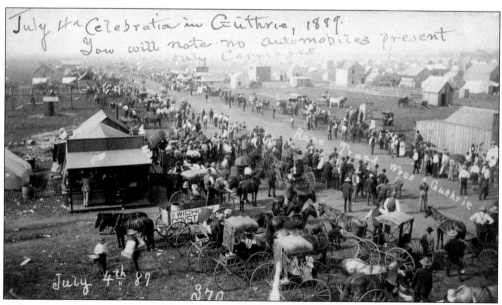

A CROWD AT A HORSE RACE. Part of the Fourth of July celebration in 1889 at Guthrie was a horse race on the west side of town. There are no grandstands, just people lined along the route that the horses would take. (Courtesy Archives Division, Oklahoma Historical Society.)

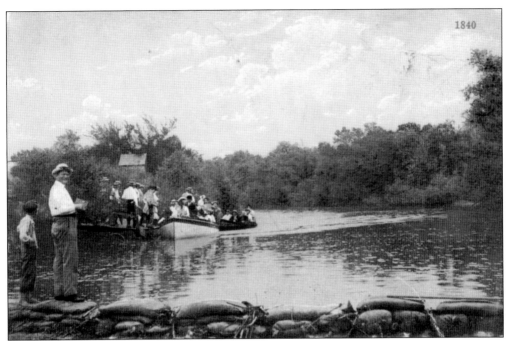

PEOPLE IN A BOAT. Guthrie's position on Cottonwood Creek made it a popular spot for many activities. Shown is the boat landing at White City bathing beach in Guthrie, probably not too far from where the viaduct is today. (Courtesy John Stanbro.)

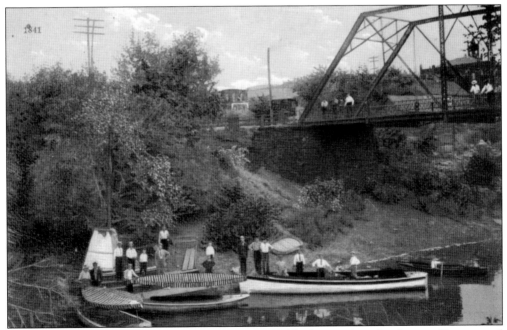

BOATS WITH A BRIDGE IN THE BACKGROUND. The Noble Avenue boat landing on Cottonwood Creek is pictured here. (Courtesy John Stanbro.)

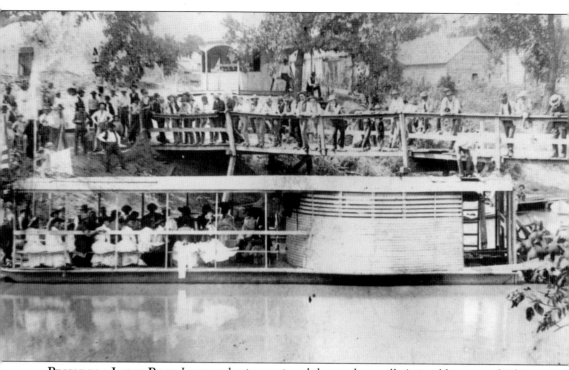

PEOPLE IN A LARGE BOAT. Large gatherings enjoyed the creek as well. A sizeable group of African Americans is seen going down the creek for a picnic. (Courtesy Bozarth Photography.)

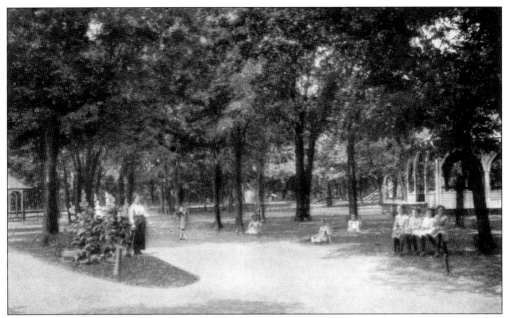

A GROUP IN THE PARK WITH A GAZEBO IN THE BACKGROUND. The settlers of Guthrie knew that parks were important to their city. This picture is of what was originally called Island Park, so named because a bend in the Cottonwood made the spot almost form an island. It is on the south side of town. (Author's collection.)

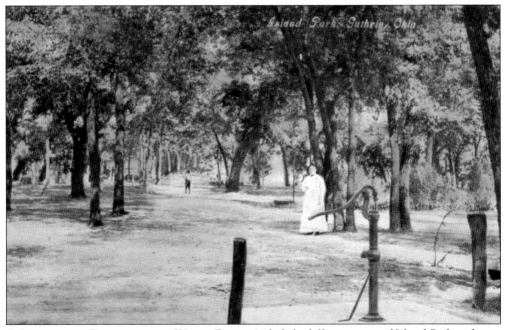

A LADY IN THE PARK BEHIND A WATER PUMP. A slightly different view of Island Park is shown here. (Author's collection.)

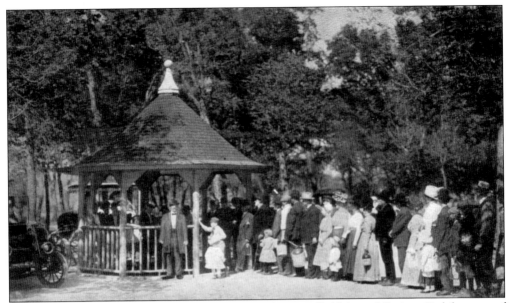

PEOPLE GOING INTO A GAZEBO. After 1908, the park was called Mineral Springs Park because of the natural springs discovered there that supposedly had medicinal properties. A large group of people waits to try the waters. (Author's collection.)

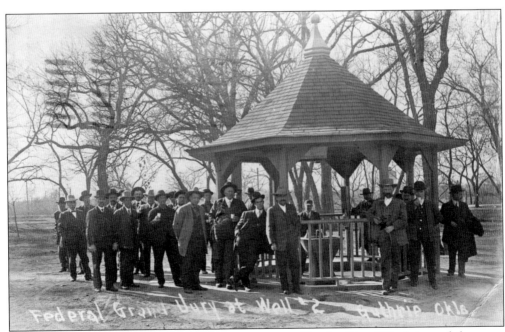

A GRAND JURY AT A GAZEBO. The springs were operated by the City of Guthrie, and there was some concern about their cleanliness. This is a picture of a federal grand jury at Well No. 2, on March 11, 1911. (Courtesy Archives Division, Oklahoma Historical Society.)

Entrance to Highland Park, Guthrie, Okla.

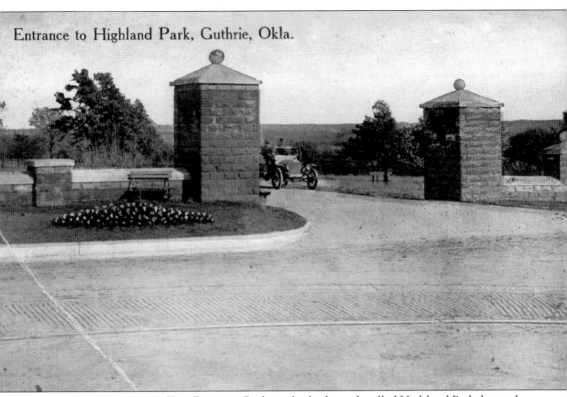

A Car Emerging between Two Pillars. Guthrie also had a park called Highland Park, located on the northeast side of town. A car is seen here driving out of the park. (Author's collection.)

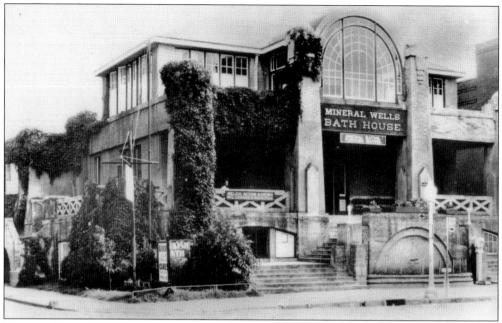

MINERAL WELLS BATH HOUSE. In December 1913, Guthrie opened the Mineral Wells Bath House. It stood at the corner of Oklahoma Avenue and Wentz Street. This picture was probably taken in the 1930s. The structure was torn down in 1947. (Courtesy Bozarth Photography.)

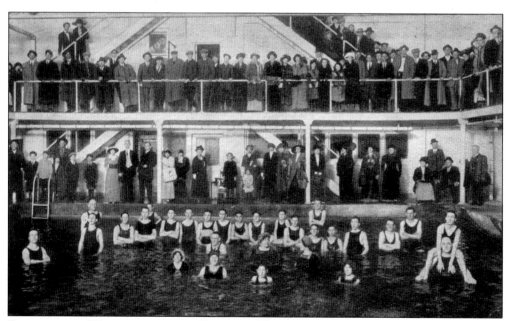

PEOPLE IN THE WATER AND ON THE BALCONY. This unique picture was probably taken at the grand opening of the Mineral Wells Bath House on December 11, 1913. Notice the people in the water and the people on the balcony in heavy coats. (Author's collection.)

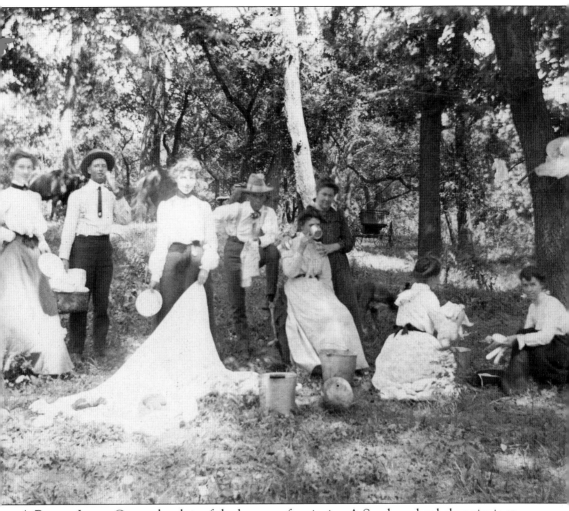

A Picnic. Logan County has lots of shady groves for picnics. A Sunday school class picnic at Pleasant Valley is shown here. (Courtesy Archives Division, Oklahoma Historical Society.)

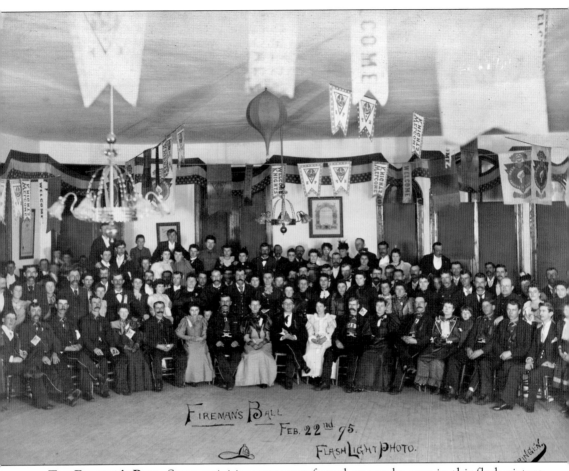

THE FIREMAN'S BALL. Some activities were more formal, as can be seen in this flash picture at the Guthrie Fireman's Ball on February 22, 1895. (Courtesy Archives Division, Oklahoma Historical Society.)

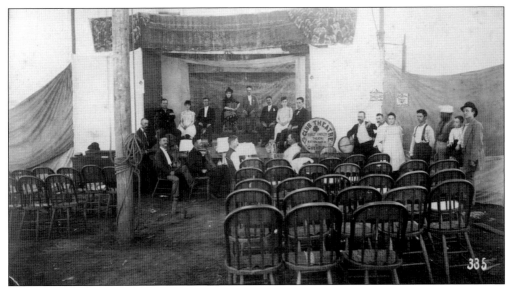

A THEATRE COMPANY. Growing towns like Guthrie were perfect locations for traveling theatrical groups. This is a photograph of the first Variety Theatre, opened in Guthrie in 1889. Its current successor, the Pollard Theater, is in operation today. (Courtesy Archives Division, Oklahoma Historical Society.)

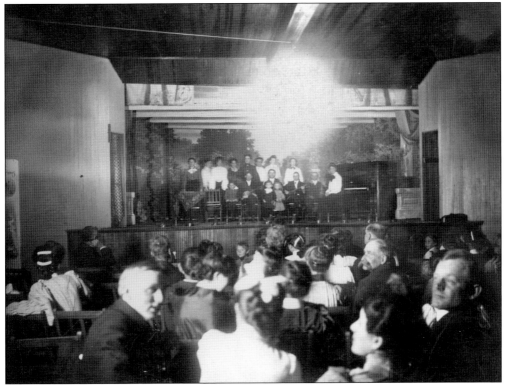

A STAGE PRODUCTION CAPTURED BY A FLASHING CAMERA. Nearly every small town had what residents termed an "opera house." Pictured here is a stage production at Coyle. (Courtesy Archives Division, Oklahoma Historical Society.)

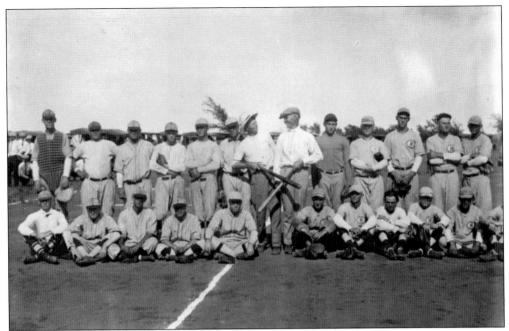

A BASEBALL TEAM. Sports were a natural way to have fun. These are the Coyle (left) and Mulhall teams (right) at a baseball game on the Fourth of July in 1924. The Coyle players are, from left to right, (seated) Jay Gaskill, unidentified, ? McCoy, Roy Hill, and Art Autry; (standing) Theron Elder, Claude Knight, Bill (Kenneth) Gephart, Esco Orendorff, Lloyd Welch, Vora Mirnich, and manager Fred Harris. Unfortunately, the Mulhall team is not identified. (Courtesy Western History Collections, University of Oklahoma.)

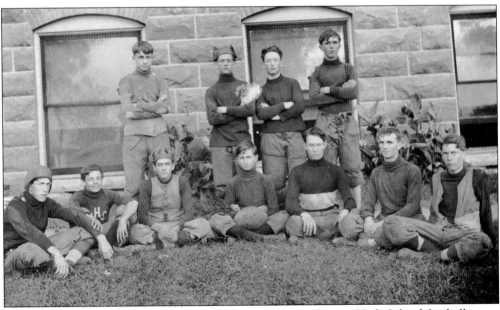

A FOOTBALL TEAM. This photograph is of the 1913 Logan County High School football team. (Courtesy Archives Division, Oklahoma Historical Society.)

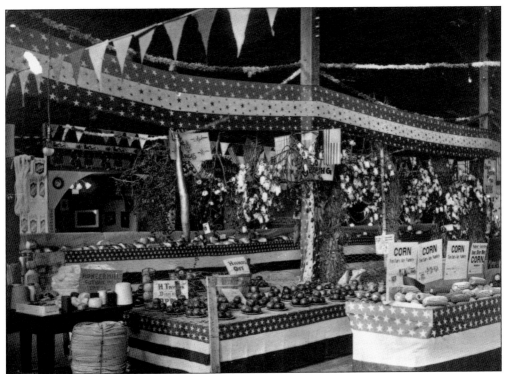

AGRICULTURAL PRODUCTS. Showing off farm products has always been both for fun and profit. Here is the Logan County Farm Show from around 1910. (Courtesy Archives Division, Oklahoma Historical Society.)

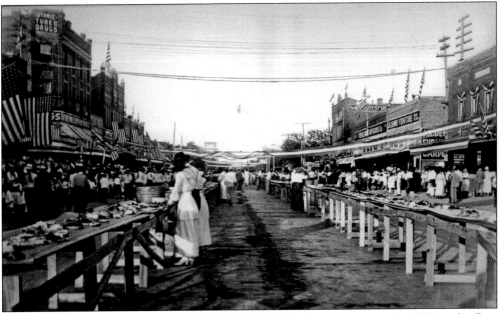

A STREET FAIR. This street fair was in Guthrie and took place sometime after 1912, as the flags have 48 stars in them. People have been eating something on the tables, perhaps watermelon, though something else has been involved as well. (Author's collection.)

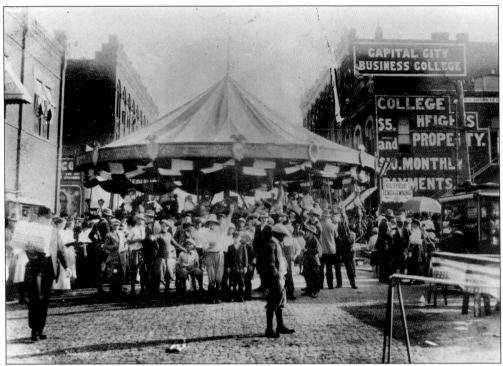

THE MERRY-GO-ROUND. This merry-go-round may date from the same street fair. R.H. Dye's popcorn machine is visible to the far right. (Courtesy Bozarth Photography.)

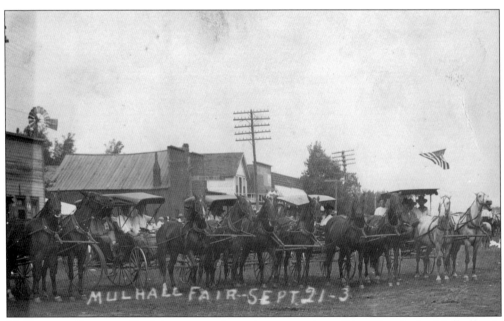

HORSES AND BUGGIES. Guthrie was not the only town to have fairs. Here is the Mulhall Fair that ran from September 21 to September 23, 1910. (Courtesy Archives Division, Oklahoma Historical Society.)

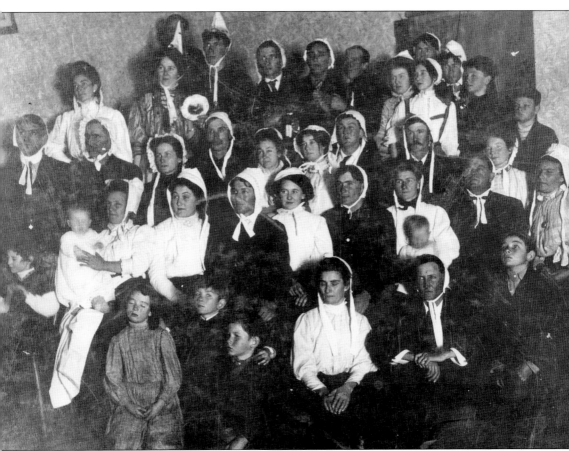

A GROUP IN NIGHTCAPS. This is a community nightcap party at Seward, sometime around 1910. Only a few of the revelers are identified, and they are (first row) Mrs. Crosley (fourth from the left), Mr. Holden (mail carrier, fifth from the left); (second row) Mrs. McMillen and baby Ruth (far left); (third row) Mary Crosley (sixth from left) and Luther Corn (seventh from left). Most of the children in the photograph look pretty sleepy. (Courtesy Western History Collections, University of Oklahoma.)

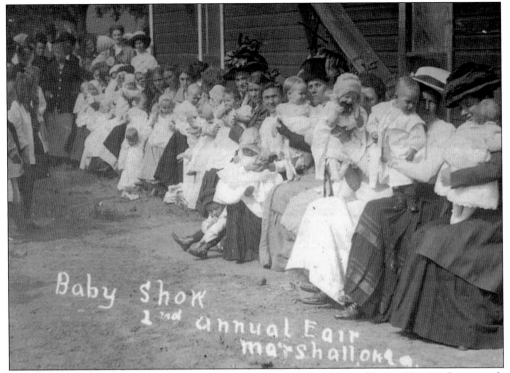

LADIES WITH BABIES, C. 1890. Community activities took a variety of forms. Here is the second-annual Ladies and Babies Day in Marshall, Oklahoma. Some of the babies look happy and some do not look as pleased. (Courtesy Bill Diedrich.)

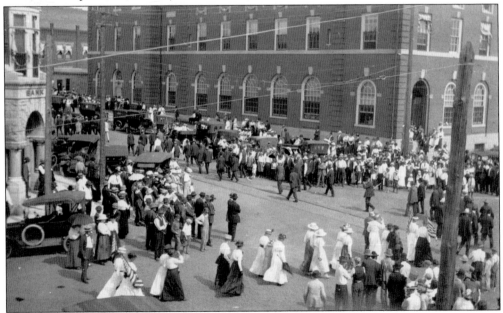

MEN MARCHING. Some activities had a more serious purpose. Seen here in 1918, a group of men in Guthrie is heading to World War I, marching off to join the US Army. (Courtesy Archives Division, Oklahoma Historical Society.)

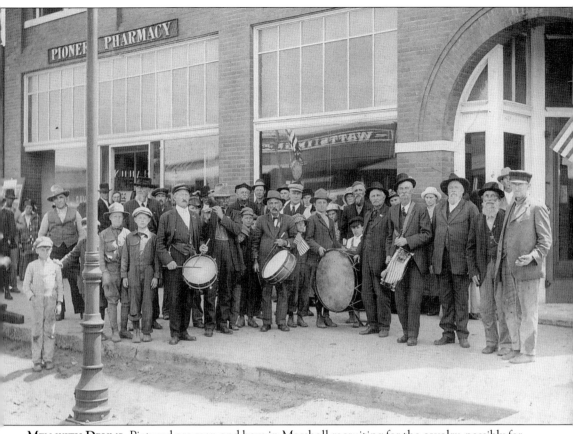

MEN WITH DRUMS. Pictured are men and boys in Marshall recruiting for the cavalry, possibly for the Spanish-American War of 1898. (Courtesy Cherokee Strip Regional Heritage Center.)

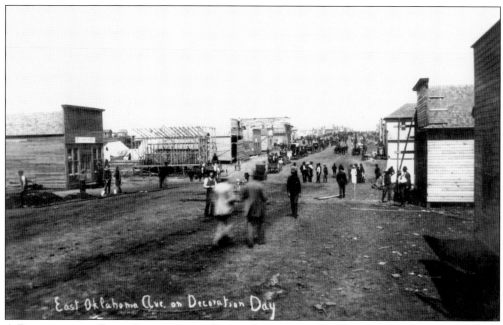

East Oklahoma Ave. on Decoration Day

A PARADE IN THE EARLY DAYS. Even at the very beginning, Guthrie specialized in parades. Here is East Oklahoma Avenue with a parade on Decoration Day (Memorial Day) in 1889. Notice that some of the buildings are still under construction. (Courtesy Archives Division, Oklahoma Historical Society.)

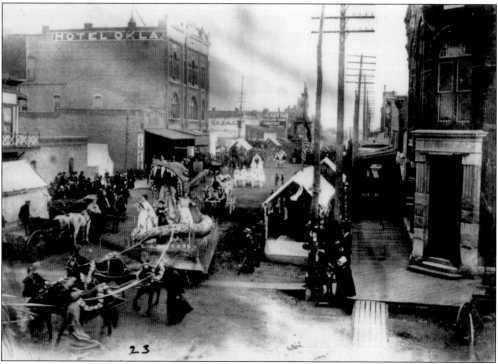

A PARADE WITH FLOATS. Guthrie's parades progressed through the years, adding floats to the lineup. (Courtesy Bozarth Photography.)

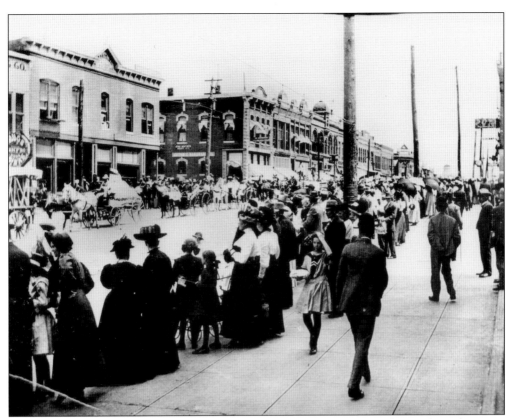

A Parade with Men Walking. Here is another parade in Guthrie. It is obvious from the image that the town's development has taken many strides. (Courtesy Bozarth Photography.)

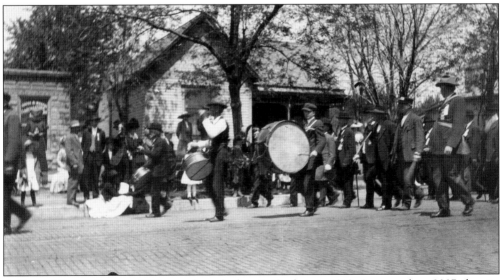

A Close-Up of a Parade. This parade took place in Guthrie in 1912. As recently as 2007, the city had a grand parade to celebrate the centennial of statehood. It seems Guthrie is a popular place to celebrate the accomplishments of times gone by. (Courtesy Oklahoma Territorial Museum.)

www.arcadiapublishing.com

Discover books about the town where you grew up, the cities where your friends and families live, the town where your parents met, or even that retirement spot you've been dreaming about. Our Web site provides history lovers with exclusive deals, advanced notification about new titles, e-mail alerts of author events, and much more.

Find Your Place in History.